Anne Currier
Sculpture Skulpturen

Nancy Weekly, Mary Drach McInnes, Helen Williams Drutt English

ARNOLDSCHE

AMERICAN CRAFT COUNCIL
LIBRARY

S0-ACL-576

NK
4210
C8
A5
2006

© 2006 ARNOLDSCHE Art Publishers, Stuttgart, and the authors

All rights reserved. No part of this work may be reproduced or used in any forms or by any means (graphic, electronic or mechanical, including photocopying or information storage and retrieval systems) without written permission from ARNOLDSCHE Art Publishers, Liststraße 9, D–70180 Stuttgart.

Authors Nancy Weekly, Mary Drach McInnes, Helen Williams Drutt English
Translation (English-German) Julia Vogt, Arnoldsche Art Publishers, Stuttgart
Book Design & Layout Brighten the Corners, London & Stuttgart – Frank Philippin, Billy Kiossoglou
Offset-Reproductions Repromayer, Reutlingen
Printing Raff GmbH, Riederich

This book has been printed on paper that is 100% free of chlorine bleach in conformity with TCF standards.

Bibliographic information published by Die Deutsche Bibliothek. Die Deutsche Bibliothek lists this publication in the Deutsche Nationalbibliografie; detailed bibliographic data is available on the Internet at http://dnb.ddb.de.

ISBN 3-89790-243-5
ISBN 13: 9783897902435

Made in Europe, 2006

Photo credits Anne Currier: ill. 4, 10, 11, 19, 22, 23, 26, 27, 65, 67, 68, p. 8, p. 13 below, p. 17, p. 18, p. 21, p. 22, p. 107, p. 108, p. 111; George Hrycun: p. 107 top left; Steve Myers: ill. 2, 3, 6–8, p. 7; Brian Oglesbee: ill. 1, 5, 9, 12–18, 20, 21, 24, 25, 28–64, 66, 69, 70, p. 13 above
Cover illustration Detail from illustration 30

This book has been made possible through the publisher's strong and enduring ties of friendship with Helen Williams Drutt English, Philadelphia, PA, USA. – Dieter and Dirk

This publication was made possible with the generous support of Marlin and Regina Miller, USA.

© 2006 ARNOLDSCHE Art Publishers, Stuttgart, und die Autoren

Alle Rechte vorbehalten. Vervielfältigung und Wiedergabe auf jegliche Weise (grafisch, elektronisch und fotomechanisch sowie der Gebrauch von Systemen zur Datenrückgewinnung) – auch in Auszügen – nur mit schriftlicher Genehmigung der ARNOLDSCHEN Verlagsanstalt GmbH, Liststraße 9, D–70180 Stuttgart.

Autoren Nancy Weekly, Mary Drach McInnes, Helen Williams Drutt English
Übersetzung (Englisch-Deutsch) Julia Vogt, Arnoldsche Art Publishers, Stuttgart
Buchgestaltung & Layout Brighten the Corners, London & Stuttgart – Frank Philippin, Billy Kiossoglou
Offset-Reproduktionen Repromayer, Reutlingen
Druck Raff GmbH, Riederich

Dieses Buch wurde gedruckt auf 100% chlorfrei gebleichtem Papier (entspricht damit dem TCF-Standard).

Bibliografische Information der Deutschen Bibliothek. Die Deutsche Bibliothek verzeichnet diese Publikation in der Deutschen National-bibliografie; detaillierte bibliografische Daten sind im Internet über http://dnb.ddb.de abrufbar.

ISBN 3-89790-243-5
ISBN 13: 9783897902435

Made in Europe, 2006

Bildnachweis Anne Currier: Abb. 4, 10, 11, 19, 22, 23, 26, 27, 65, 67, 68, S. 8, S. 13 unten, S. 17, S. 18, S. 21, S. 22, S. 107, S. 108, S. 111; George Hrycun: S. 107 oben links; Steve Myers: Abb. 2, 3, 6–8, S. 7; Brian Oglesbee: Abb. 1, 5, 9, 12–18, 20, 21, 24, 25, 28–64, 66, 69, 70, S. 13 oben
Titelabbildung Detail aus Abb. 30

Dieses Buch ist zustande gekommen durch die tiefe Freundschaft zu Helen Williams Drutt English, Philadelphia, PA, USA. – Dieter und Dirk

Diese Publikation wurde ermöglicht durch die großzügige Unterstützung von Marlin und Regina Miller, USA.

Contents

6
Nancy Weekly
Timeless Balance: The Ceramic
Sculpture of Anne Currier

12
Mary Drach McInnes
Cadiz: The Sculptural Topology
of Anne Currier's Work

15
Helen Williams Drutt English
Mental Travel Time

25
The Work of Anne Currier
from 1987 to 2006

105
Appendix

Inhaltsverzeichnis

6
Nancy Weekly
Zeitloses Gleichgewicht: Anne
Curriers keramische Skulpturen

12
Mary Drach McInnes
Cadiz: die plastische Topologie
von Anne Curriers Werk

15
Helen Williams Drutt English
Eine Reise in die Erinnerung

25
Arbeiten von Anne Currier
1987–2006

105
Anhang

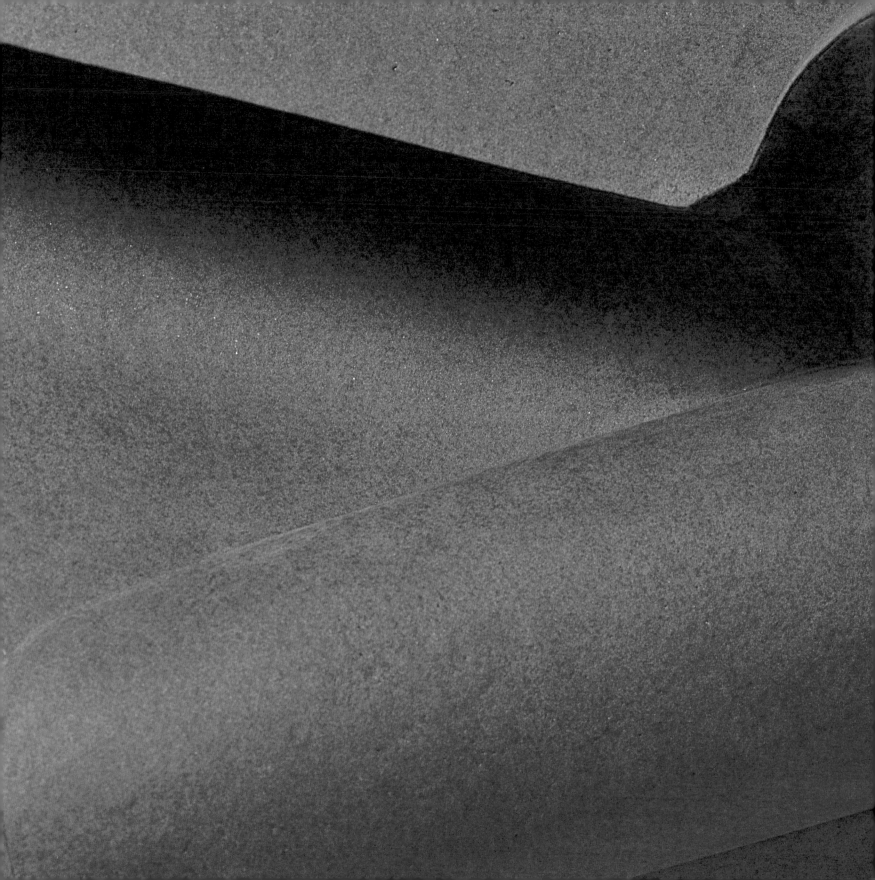

3 Essays on the Work of Anne Currier
by Nancy Weekly, Mary Drach McInnes and
Helen Williams Drutt English

3 Essays zur Arbeit von Anne Currier
von Nancy Weekly, Mary Drach McInnes und
Helen Williams Drutt English

**Timeless Balance: The Ceramic Sculpture of Anne Currier
by Nancy Weekly**

In the second century B.C.E., Huai-nan Tzu (also known as Liu An) wrote: "Before heaven and earth had taken form all was vague and amorphous. Therefore it was called the Great Beginning. The Great Beginning produced emptiness and emptiness produced the universe … . The combined essences of heaven and earth became the yin and yang, the concentrated essences of the yin and yang became the four seasons, and the scattered essences of the four seasons became the myriad creatures of the world."

So much of what we know of history and ancient cultures, we have deduced from archaeological remains and aesthetic remnants. Architectural structures – or more often their undestroyed components such as columns, foundations, stone blocks and other fragments – suggest cultural history, rituals, hierarchies and social intercourse. Painting survives if the surface upon which it was applied was strong enough to resist disintegration. Prehistoric cave paintings in Altamira were hidden in secluded caves; Egyptian dynastic chronicles and mythology were interred in tombs; figures on Greek and Roman amphorae, kylixes and other ceramic vessels memorialize the dead and tell stories about the gods. Perhaps the most powerful evidence resides in sculpture, particularly figurative sculpture, from the small fecund fetish totem known as the Venus of Willendorf to the colossal mountain-carved Buddhas in Asia. Anne Currier's ceramic sculpture carries with it a weightiness of significance that prevails in ancient sculpture, while at the same time, it projects our contemporary experience. Everything about it evokes a multitude of characteristics: complex yet fragmentary, fleshy but cool as stone, rounded and angular with sharp flat planes intersecting softly curving arcs. This series of contrasts relies on differences to set up the intrigue that pulls you around all sides to discover unexpected vistas unfolding.

In the beautifully illustrated book that documented the comprehensive exhibition *Color and Fire: Defining Moments in Studio Ceramics, 1950–2000* presented by the Los Angeles County Museum of Art, Anne Currier's clay sculpture *Panel Series I: Frolic* 1997 (see ill. 21), from the museum's collection, illustrates the section titled "What You See Is What You See": A Defining Moment for the Twenty-First Century." The quote taken from American painter Frank Stella refers to the basic premise behind contemporary art: that the viewer must face the challenge to draw upon personal experience and knowledge to read artwork. While the artist creates an object with certain intentions, its meaning cannot be limited to a single vision. Interpretation is subjective. We each bring our individual associations, looking for clues from the unconscious, Swiss professor Ferdinand de Saussure's theory of "the linguistic sign," and mathematical structures. Saussure's theory for the linguistic sign, presented in lectures between 1907 and 1911, demonstrated a difference between a concept of a thing, which he termed a "signified," and a sound image associated with the concept, which he called a "signifier." Lacan inverted Saussure's terms to create an algorithm for the function of speech and a paradigm for the structure of the unconscious. He is best known for his statement: "The unconscious is structured like a language." To follow the Lacanian model, each signifier refers to another signifier, linked in a chain of signification. However, language is divided into two functions: metonymy and

**Zeitloses Gleichgewicht: Anne Curriers keramische Skulpturen
von Nancy Weekly**

Im 2. Jahrhundert v. Chr. schrieb Huai-nan Tzu, der auch als Liu An bekannt ist: „Bevor Himmel und Erde Gestalt annahmen, war alles unklar und formlos. Deshalb wurde es der Große Ursprung genannt. Dieser Große Ursprung brachte Leere hervor und diese Leere wiederum das Universum … . Die kombinierten Wesen von Himmel und Erde wurden zu Yin und Yang, die vereinigten Wesen von Yin und Yang zu den vier Jahreszeiten und die verstreuten Essenzen der vier Jahreszeiten wurden die unzähligen Geschöpfe der Welt."

Vieles davon, was wir über die Geschichte und alte Kulturen wissen, haben wir aus archäologischen Überresten und noch erhaltenen Kunstwerken aus vergangener Zeit gelernt. Architektonische Strukturen oder ihre nicht zerstörten Bestandteile wie z.B. Säulen, Fundamente, Steinblöcke und andere Bruchstücke sind die Zeichen einer Kulturgeschichte, Zeichen von Ritualen, Hierarchien und gesellschaftlichem Umgang. Ein Gemälde übersteht die Zeit, wenn die Fläche, auf die es aufgetragen wurde, stark genug ist, sich der Auflösung zu widersetzen. Prähistorische Höhlenmalereien in Altamira wurden in abgeschiedenen Höhlen versteckt; ägyptische Aufzeichnungen von Dynastien und Mythologien haben in Grabstätten überdauert; Figuren auf griechischen und römischen Amphoren, Kylixen und anderen keramischen Gefäßen gedenken der Toten und erzählen Geschichten über die Götter. Das vielleicht mächtigste Zeugnis geben Skulpturen, insbesondere figürliche Skulpturen, ab: von dem kleinen, als Venus von Willendorf bekannten Fruchtbarkeitsfetisch-Totem bis zu den riesigen, aus Bergen gehauenen Buddhas in Asien.

Anne Curriers keramische Skulpturen tragen eine Bedeutung in sich, die man schon bei antiken Skulpturen antrifft; gleichzeitig vermittelt sie unsere zeitgenössischen Erfahrungen. Ihr Werk beschwört eine Vielzahl von Eigenschaften herauf: komplex, aber dennoch fragmentarisch, fleischig, aber kalt wie Stein, gerundet und eckig mit scharfen, flachen Ebenen, die sich mit gekrümmten Bogen kreuzen. Diese Gegensätze erzeugen eine Faszination, die einen Anne Curriers Objekte von allen Seiten betrachten lässt, um so unerwartete Perspektiven zu entdecken.

In dem sehr schön bebilderten Buch zur Ausstellung *Color and Fire: Defining Moments in Studio Ceramics, 1950–2000*, die vom Los Angeles County Museum of Art gezeigt wurde, illustriert Anne Curriers Tonskulptur *Panel Series I: Frolic* 1997 (s. Abb. 21) aus der Museumssammlung den „What You See is What You See': A Defining Moment for the Twenty-First Century" („,Was man sieht, ist, was man sieht': ein entscheidender Moment für das 21. Jahrhundert") benannten Bereich. Das vom amerikanischen Maler Frank Stella stammende Zitat bezieht sich auf die grundlegende Voraussetzung zeitgenössischer Kunst: dass der Betrachter sich der Herausforderung stellen muss, sich auf seine persönliche Erfahrung und sein individuelles Wissen zu stützen, um ein Kunstwerk zu lesen. Obgleich der Künstler ein Objekt mit einer bestimmten Absicht erschafft, kann dessen Bedeutung nicht auf eine einzige Sichtweise begrenzt werden. Jede Interpretation ist subjektiv, denn wir alle haben unsere ganz individuellen Assoziationen. Auch wenn wir nach Hinweisen des Künstlers suchen, besteht die größte Bedeutung in dem Austausch, der zwischen Kunstwerk und Betrachter stattfindet. Das schließt nicht aus, Neues zu lernen und von dem eigenen, begrenzten Bezugsbereich in die Welt geschleudert zu werden, die immer größer ist, als wir sie uns vorgestellt hatten.

In der zweiten Hälfte des 20. Jahrhunderts wurden Kunsthistoriker, Akademiker und Literaturwissenschaftler von früheren psychoanalytischen Vorstellungen über den Zusammenhang zwischen dem Unbewussten, Sprache und Verlangen beeinflusst. Sehr vereinfacht ausgedrückt, entwickelte der vorherrschende Theoretiker, der französische Psychoanalytiker Jacques Lacan (1901–1981), Theorien, die auf Sigmund Freuds Entdeckung des Unbewussten um 1900, auf der Theorie über das „linguistische Zeichen" des Schweizer Professors Ferdinand de Saussure und auf mathematischen Strukturen basierten.

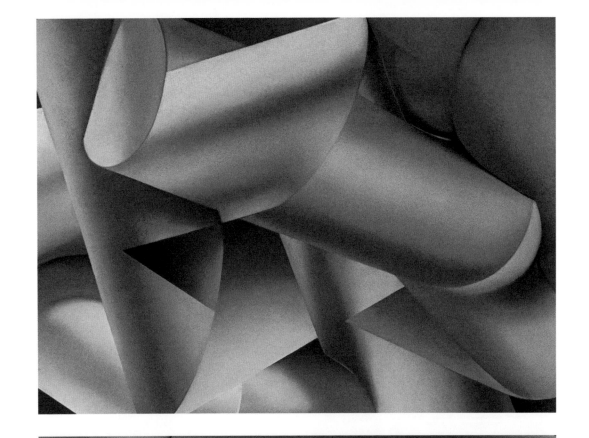

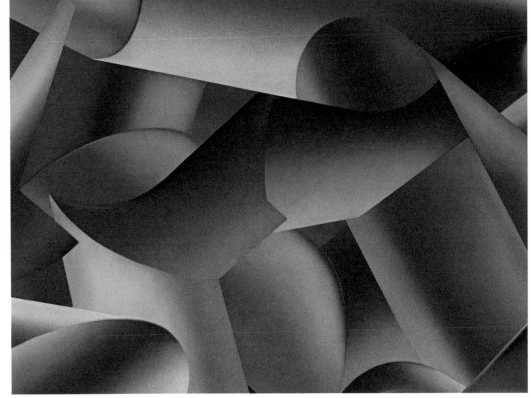

Circumflexor #3
1988, hard pastel on board, 40 × 32 in.
Marlin and Regina Miller, USA
1988, harter Pastellstift auf Karton, 101,6 × 81,3 cm
Marlin und Regina Miller, USA

Circumflexor #13
1989, hard pastel on board, 40 × 32 in.
Collection of the artist
1989, harter Pastellstift auf Karton, 101,6 × 81,3 cm
Sammlung der Künstlerin

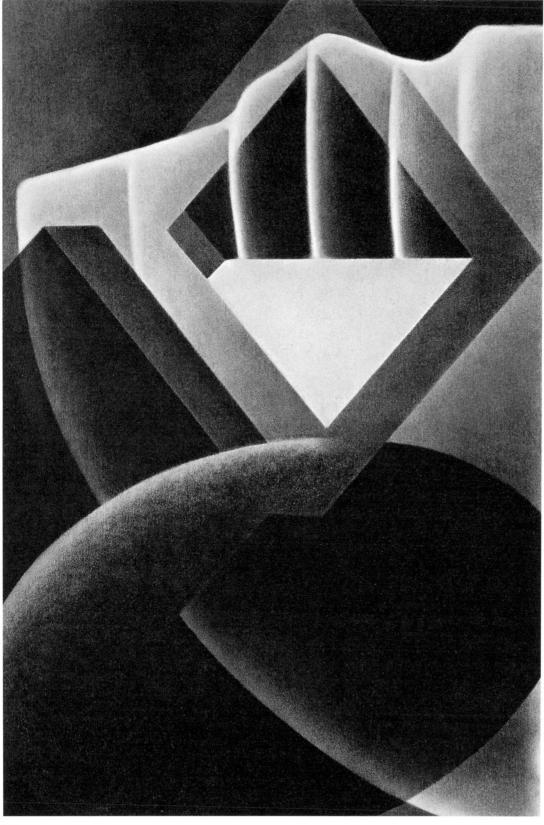

Convocation: Study #5
1995, charcoal on board, 18 × 28 in.
Marlin and Regina Miller, USA
1995, Kohle auf Karton, 45,7 × 71,2 cm
Marlin und Regina Miller, USA

metaphor. Connections between signifiers are metonymic; meaning one word can be used to connote something to which it is logically associated, such as "crown" for "sovereignty." "Metaphor functions differently, drawing connections between two unrelated terms, perhaps unexpectedly. Lacan believed that the unconscious operates in the same manner. Words, even parts of words, and images, including those in our rebus dreams, interconnect in often paradoxical ways that can be examined to uncover separate elements and their evoked associations. This said, Anne Currier's sculptures beg interpretation through perception and analysis by linking associations of its individual parts.

Setting the stage, many of Currier's sculpture friezes from the late 1990s openly acknowledge sensuality. Titles corroborate what we see in fragments as light spills across surfaces, creating form-defining shadows in deep folds and cavities. *Panel Series II: In the Shallows* (see ill. 31) portrays a Botticellian Venus emerging from the sea, coaxed by attendants made visible by a flexed arm and bent knee. Full, fleshy forms sink into soft surfaces in *Panel Series II: Embrace* (see ill. 30); the intertwined interior and exterior curves of limbs suggesting the psychological depth of lovers' impassioned exploration of their bodies. A kneeling figure straddles a reclining female nude in *Panel Series II: Arousal* (see ill. 29). Such voluptuousness has its precedents, like the undulating marble figure, *La Danaïde*, by Auguste Rodin, believed to have been inspired by his lover, the artist Camille Claudel. Currier's figurative eroticism is even more reminiscent of the stone friezes of the tenth century Jain temple of Khajuraho in Northern India. Covering the outer walls, Shiva and Shakti, as well as other Hindu gods and goddesses, demonstrate more sexual postures and positions that are meant to evoke the "perfect godly union" that combines Tantric spirituality with physical pleasure. In addition, Currier loves the iconic temple friezes from the Greek Parthenon for their "limitations of compression" of the figures within the geometry of the triangular pediment.[1]

While concave and convex curves might still convey a sense of human anatomy, Currier's columnar forms become more abstract and architectonic beginning in 1999. *Juncture* (see ill. 33), for example, is a twisted body of truncated and tapered cylinders defying gravity. Caught in motion, although not as flared or human as Boccioni's Futurist sculpture *Unique Forms of Continuity in Space* (1913), *Juncture* has a kinetic quality. Its mysterious parts seem to rise, tumble or spin from various axis points. *Set-Up* (see ill. 37) introduces elegant architectural forms, such as the flared cone we associate with Frank Lloyd Wright's temple to Modernism: the Solomon R. Guggenheim Museum in New York. Its outer surface suggests the circular structure of space within. This volumetric play of interior space as defined by visible outer dimensions continues to drive Anne Currier's aesthetic.

Homage (see ill. 45) from 2001 evokes many associations. That date haunts all Americans; so naturally we first think of this sculpture as homage to the fallen towers and lost lives in New York, Virginia and Pennsylvania. The blue-black mottled surface resembles marble, the stone associated with funerary memorials. Yet, the three graceful interlocking planar masses suggest unity, like the three linked Borromean rings of topological mathematics.[2] At the same time that this sculpture holds personal references for the artist (in deference to an inspirational sculpture), it also visually summons up prehistoric, megalithic Stonehenge, a mysterious earthwork that continues to motivate interpretation five thousand years after its creation. Because of both its title and its composition, Currier's *Homage* operates as a powerful universal symbol, capable of representing something or someone of significance whom we respect and honor.

From that point on, Currier's work has grown increasingly sophisticated. Paradoxically, as she uses fewer elements, the forms themselves are surprisingly complex. Is it possible to call her sleek Modernist forms Baroque? Diagonals, flared shapes, trapezoids, ellipses, oblique angles, and intersecting volumes continually offer unanticipated drama. Among her free-standing sculptures of

Saussures Theorie über das linguistische Zeichen, die er in Vorlesungen zwischen 1907 und 1911 vorstellte, veranschaulichte einen Unterschied zwischen dem Konzept einer Sache, welches er „Signifikat", also „Bezeichnetes", nannte, und dem Klangbild, das mit diesem Konzept assoziiert wird, welches er „Signifikant" nannte, also „Bezeichnendes." Lacan vertauschte Saussures Begriffe, um einen Algorithmus für die Sprachfunktion und ein Muster für die Struktur des Unbewussten zu entwerfen. Am bekanntesten ist seine Aussage: „Das Unbewusste ist wie eine Sprache strukturiert." Lacan zufolge bezieht sich jeder Signifikant auf einen anderen Signifikanten; sie sind in einer Signifikantenkette miteinander verbunden. Jedoch wird die Sprache in zwei Funktionen unterteilt: Metonymie und Metapher. Verbindungen zwischen Signifikanten sind metonymisch, d.h. ein Wort kann verwendet werden, um etwas zu bezeichnen, mit dem es logisch assoziiert wird, zum Beispiel „Krone" für „Staatshoheit". Oft steht ein Teil des Bezeichneten für das Ganze, wie in „Eisen" für „Schwert". Die Metapher funktioniert auf andere Weise. So zieht sie auch unerwartete Verbindungen zwischen zwei Begriffen, die in keiner Beziehung zueinander stehen. Lacan vertrat die Ansicht, dass das Unbewusste auf dieselbe Weise arbeitet. Wörter, sogar nur Wortteile, und Bilder, einschließlich derjenigen aus unseren Rebus-Träumen (Freud versteht den Traum gleich einem Rebus, einem Bilderrätsel), verbinden sich auf oft paradoxe Weise. Würde man diese Verbindungen genauer untersuchen, so könnte man ihre Einzelbestandteile und ihre hervorgerufenen Assoziationen aufdecken. In Folge dieser Überlegungen fordern Anne Curriers Skulpturen zur Interpretation durch Wahrnehmung und Analyse auf, indem die aufgekommenen Assoziationen verbunden werden.

Viele von Curriers „plastischen Friesen" aus den späten 1990er Jahren bekennen sich offen zur Sinnlichkeit und sind in dieser Hinsicht wegbereitend. Die Namen der Kunstwerke bekräftigen, was wir in Fragmenten sehen, wenn sich Licht über die Oberfläche ergießt und so formgebende Schatten in tiefen Falten und Hohlräumen hervorbringt. *Panel Series II: In the Shallows* (In den Untiefen, s. Abb. 31) stellt eine Venus in der Art Botticellis dar, die aus dem Meer auftaucht und von schmeichelnden Begleitern umgeben ist, welche durch einen gebeugten Arm und ein gebogenes Knie sichtbar gemacht werden. Volle, fleischartige Formen sinken in nachgebende Oberflächen in *Panel Series II: Embrace* (Umarmung, s. Abb. 30); die ineinander greifenden inneren und äußeren Kurven der Gliedmaße suggerieren die psychologische Tiefe der leidenschaftlichen Erforschung der Körper der Liebenden. Eine kniende Figur sitzt rittlings auf einer liegenden, nackten Frau in *Panel Series II: Arousal* (Erregung, s. Abb. 29). Eine solche Wollust hat Vorgänger, wie die wellenförmige Marmorfigur *La Danaïde* von Auguste Rodin, von der man annimmt, sie sei von seiner Geliebten, der Künstlerin Camille Claudel, inspiriert. Noch stärker erinnert Curriers figürliche Erotik an Steinfriese des aus dem 10. Jahrhundert stammenden Jain-Tempels in Khajuraho im nördlichen Indien. Die Außenwände dieses Tempels zeigen Shiva und Shakti sowie weitere Hindu-Gottheiten, die sexuelle Haltungen und Positionen veranschaulichen, die dazu bestimmt sind, die „vollkommene göttliche Vereinigung" heraufzubeschwören, welche tantrische Spiritualität mit körperlichem Vergnügen verbindet. Darüber hinaus liebt Currier die ikonischen Tempelfriese des griechischen Parthenon aufgrund der architektonisch bedingten Begrenzung der Figuren innerhalb der Geometrie des Giebeldreiecks.[1]

Während Hohlräume und konvexe Kurven immer noch ein Gefühl von menschlicher Anatomie vermitteln mögen, werden Curriers säulenartige Formen seit 1999 immer abstrakter und architektonischer. *Juncture* (Verbindungspunkt, s. Abb. 33) zum Beispiel ist ein verbogener Körper bestehend aus kegelstumpf-artigen und spitz zulaufenden Zylindern, die der Schwerkraft trotzen. In der Bewegung festgehalten, wenn auch nicht so aufbrausend oder menschlich wie Boccionis futuristische Skulptur *Einzigartige Formen der Kontinuität im Raum* (1913), besitzt *Juncture* doch ein kinetisches Wesen. So scheinen die rätselhaften Bestandteile von verschiedenen Achsenpunkten aus zu steigen, zu fallen oder sich zu drehen. *Set-Up* (Anordnung, s. Abb. 37) lässt elegante

architektonische Formen einfließen wie zum Beispiel den sich erweiternden Kegel, den wir mit Frank Lloyd Wrights Tempel des Modernismus assoziieren: dem Solomon R. Guggenheim Museum in New York. Seine äußere Fläche deutet auf die kreisförmige Raumstruktur im Inneren. Dieses volumetrische Spiel mit dem Innenraum, der von sichtbaren äußeren Dimensionen definiert ist, ist weiterhin die treibende Kraft von Anne Curriers Ästhetik.

Homage (Huldigung, s. Abb. 45) aus dem Jahre 2001 ruft viele Assoziationen hervor. Dieses Jahresdatum verfolgt alle Amerikaner; so betrachten wir diese Skulptur zunächst ganz selbstverständlich als Huldigung an die gefallenen Türme und verlorenen Leben in New York, Virginia und Pennsylvania. Die blauschwarz gefleckte Oberfläche ähnelt Marmor, also dem Stein, der mit Grabmälern assoziiert wird. Die drei anmutigen, ineinander greifenden ebenen Massen suggerieren jedoch eine Einheit, wie die drei miteinander verbundenen Borromäischen Ringe in der topologischen Mathematik.[2] Darüber hinaus birgt diese Skulptur nicht nur persönliche Bezüge für die Künstlerin (als Ehrerbietung gegenüber einer inspirativen Skulptur), sondern erinnert visuell auch an das prähistorische, megalithische Stonehenge, ein rätselhaftes Monument, das auch fünf Jahrtausende nach seiner Erschaffung Anlass zu Spekulationen gibt. Aufgrund seines Titels und seines Aufbaus wirkt Curriers Homage als mächtiges universelles Symbol, das in der Lage ist, etwas oder jemand Bedeutendes zu verkörpern, das oder den wir respektieren und ehren.

Ab 2001 sind in Curriers Werk immer mehr raffiniertere Züge auszumachen. Paradoxerweise sind die Formen überraschend komplex, obwohl sie weniger Elemente verwendet. Kann man ihre geschmeidigen, modernistischen Formen barock nennen? Diagonalen, sich erweiternde Formen, Trapeze, Ellipsen, schiefe Winkel und sich kreuzende Teile bieten immer wieder ein unerwartetes Schauspiel. Von ihren frei stehenden Skulpturen aus dem Jahre 2002 bietet Contraction (Kontraktion, s. Abb. 48) einen sinnlichen Kontrast zwischen glatten, runden Formen und scharfen amboss- und speerartigen Ecken und Kanten. Ein niedriger Teil von First of June (Der erste Juni, s. Abb. 39), der aus verwobenen Turbinen und Hohlräumen hervorragt, schwebt heiter über dem Sockel. Pivotal Moment (Entscheidender Moment, s. Abb. 47) umarmt den Boden, krümmt sich aber nach oben, als ob die Skulptur geometrische Bewegungen im Raum abstecke, vergleichbar einem Fotostandbild mitten in der Bewegung.

Curriers erstaunliche Präzision bei der Gestaltung ihrer Werke lässt uns für einen Moment vergessen, dass sie die Objekte aus Ton von Hand formt. Ihr Werk erscheint monumental, als ob es aus massivem Stein oder Metall sei. Man könnte sich leicht vorstellen, dass es Tonnen schwer ist, ähnlich wie Richard Serras gedrehte Platten aus Corten-Stahl, die unsere Existenz so klein erscheinen lassen. Currier sagt selbst, dass die Konstruktion ihrer Stücke eine Herausforderung sei. Seitdem sie realisierte, dass ihre Hand während des Formens immer innerhalb ihres Werkes sei, betrachte sie die Masse als etwas, das durch die Hohlräume herausgedrückt werde.[3] Ihre Technik sei teilweise von der als Pilobolus bekannten Tanzgruppe inspiriert, die sie in Boulder, Colorado, gesehen habe und die sich während ihrer Aufführung Latexkleidung abstreife. Die Tänzer schienen „innerlich gefangen zu sein und sich langsam zu bewegen".[4] Diese choreographierte Bewegung kreativen Drucks von innen erzwingt die Bildung der tatsächlichen Haut ihrer hohlen Skulpturen. In den letzten ein bis zwei Jahren versuchte sie, die Formen zu reduzieren[5], so dass diese minimal, jedoch keine alltäglichen geometrischen Gestaltungen sind.

Neben der Entwicklung von Formenvariationen experimentiert Currier mit verschiedenen Oberflächenbearbeitungen, die oft in Bezug zu den glatten, verwitterten, mit Flechten bedeckten Steinen – wie z.B. dem grauen Schieferstein – ihres Zuhauses in Scio, Allegany County, NY, stehen. Scio liegt nahe des New York State College of Ceramics der Alfred University, wo sie eine Professorenstelle innehat und einst Vorsitzende war. Darüber hinaus ist sie von anderen Oberflächen fasziniert, die ihr Zuhause und ihr Studio umgeben bzw. Teil derselben sind, so z.B. oxidierte Zinnlampenschirme oder das dunkle Eisen eines dickbäuchigen Ofens oder die zarten Holztöne eines handgefertigten

2002, Contraction (see ill. 48) offers a sensuous contrast between smooth, rounded forms and impossibly sharp anvil and spear-like angles. A lower portion of First of June (see ill. 39) hovers buoyantly over the pedestal, jutting out from enmeshed turbines and cavities. Pivotal Moment (see ill. 47) hugs the ground, yet arches up as if defining geometric movements in space caught in stop-action photography.

Currier's amazing precision in sculpting makes us momentarily forget that she is hand-building forms out of clay. Her work appears monumental, as if it were solid stone or metal. It would be easy to imagine it weighing tons, similar to Richard Serra's torqued, Corten steel slabs dwarfing our existence. Currier has said that engineering her pieces is a challenge. Once she realized that her hand was always inside of her work during its creation, she has thought of the mass as being "pushed out by the voids."[3] She likened her technique, in part, to have been inspired by the dance troupe known as Pilobolus, which she saw in Boulder, Colorado, pulling off latex clothing as part of their act. The dancers seemed to be "caught inside and moving slowly."[4] This choreographed movement of creative pressure from the inside forces the formation of the virtual skin of her hollow sculptures. For the past year or two, she has been "really trying to pare it down"[5] so that the forms are minimal, but not quotidian geometric archetypes.

In addition to developing variations in forms, Currier has been experimenting with different glazes and finishes that often relate to the smooth, weathered and lichen-covered stones, such as gray shale, from her Allegany County home in Scio, near the New York State College of Ceramics at Alfred University where she is a professor and former chairperson. She is intrigued by other natural surfaces surrounding or incorporated in her home and studio, like oxidized tin lamp shades or the dark iron of a pot-bellied stove or mellow wood tones of a handmade cherry table. One of her favorite artworks inspired her dark, nearly black glazes. Every time she is in Chicago, she goes to the Art Institute to see Raymond Duchamp-Villon's bronze The Horse (1914); and when she is in Washington, DC, she visits another cast of the same work at the Hirshhorn Museum and Sculpture Garden.[6] (This French Cubist work no doubt also aroused her interest in abstract, kinetic form.) However, Currier's sculptures are not always monotone. The sharp edges she achieves on her sculptures are sometimes enhanced by applying a lighter or darker color to the perimeter to contrast with the main body of the work. This outlining, so to speak, incorporates a rune from an unknown language, its puzzle piece curves suggesting how it might nestle within a larger entity.

Spare abstraction that still evokes a graceful human presence can be seen in the obsidian hued Belmont 2004 (see ill. 57), which calls to mind Constantin Brancusi's early 20th-century portraits of Mademoiselle Pogany or other female muses, with a gently tilting curve of its cranial form resting on a supple shoulder. Wadsworth 2004 (see ill. 51), on the other hand, appears more like a glyph, something fallen from an architectural monument, akin to elements from urban aluminum and neon sculpture by Chryssa. Wadsworth is a conundrum of a rune from an unknown language, its puzzle piece curves suggesting how it might nestle within a larger entity.

The cosmic blackness of the works from 2004 is gone in Currier's newest sculptures from 2005. Seductive surfaces reflect a lighter palette of ivory, shale green, terra cotta, granite, sandstone, and hornblende. Angelica (see ill. 60) recalls some of the tilted planes of Belmont, but it veers from human proportions. While suggesting the monumental quality of ancient Cycladic figures (c. 3000–2000 B.C.E.), the triangular slab's angularity makes it more nonrepresentational. The unique purity of gently arching, pristinely fitted, organic yet igneous forms of Currier's new work summarizes the advancements she has made technically, as well as conceptually. Each perspective yields a succinctness exclusive to the experience of viewing her wall pieces from side to side or circumventing her free-standing pieces in the round. The names refer to towns, but can have multiple meanings, as would delight Marcel Proust who introduced the idea of

"Place-Names" in *A la Recherche du Temps Perdu*, known in English as *In Search of Lost Time*.[7] *Shongo* (see ill. 62), for example, refers to a town in Allegany County, an African god of fire (appropriately relating to firing a kiln), and mathematical network theory derived from Congo Basin games in which you must redraw patterns without retracing your path or lifting your pencil from the page (and sometimes there is more than one solution). The enduring quality of Anne Currier's balanced sculptures leads us back to the initial idea of their containing the yin and yang, the concentrated essences of the world. Her exquisite work articulates space with an understanding of human vitality while speaking individually with the brevity of a discriminating language of light, shadow, surface, and mass.

[1] Interview with the artist by Nancy Weekly, September 7, 2005.

[2] The Borromean rings, or knot, appear in art of various cultures and were also used by Jacques Lacan to illustrate his theory.

[3,4,5,6] Interview, September 7, 2005.

[7] It previously had been translated as *Remembrance of Things Past*.

Kirschholztisches. Eines ihrer Lieblingskunstwerke inspirierte ihre dunklen, fast schwarzen Glasuren. Jedes Mal, wenn sie in Chicago ist, besucht sie das Art Institute, um Raymond Duchamp-Villons Bronzefigur *Das Pferd* (1914) zu betrachten; und in Washington, DC, besichtigt sie einen anderen Guss derselben Arbeit im Hirshhorn Museum and Sculpture Garden.[6] (Dieses französische Werk des Kubismus weckte zweifellos auch ihr Interesse an abstrakten, kinetischen Formen.) Curriers Skulpturen sind jedoch nicht immer einfarbig. Manchmal betont sie die scharfen Ecken ihrer Skulpturen noch durch eine hellere oder dunklere Farbe am äußeren Rand, die mit der Hauptmasse der Arbeit kontrastiert. Dieser Umriss, sozusagen, zeigt Curriers grafisches Geschick. Indem sie hier die Form subtil durch eine Linie betont, verbindet sie ihre Zeichnung mit dem Dreidimensionalen.

Eine sparsame Abstraktion, die einen jedoch immer noch an eine anmutige menschliche Präsenz denken lässt, zeigt die obsidianfarbige Skulptur *Belmont* 2004 (s. Abb. 57) mit einer sich sachte neigenden, auf einer weichen Schulter ruhenden Schädelform, die an Constantin Brancusis Porträts des frühen 20. Jahr-hunderts von *Mademoiselle Pogany* oder anderer weiblicher Musen erinnert. *Wadsworth* 2004 (s. Abb. 51) dagegen ähnelt eher einem Bildzeichen, etwas, das von einem architektonischen Monument heruntergefallen ist, vergleichbar Elementen aus Aluminium und den Neonskulpturen der griechischen Künstlerin Chryssa. *Wadsworth* ist eine rätselhafte Rune einer unbekannten Sprache, dessen puzzleteilartige Rundungen andeuten, wie es sich in eine größere Einheit einzufügen vermag.

Die kosmische Schwärze findet sich nicht mehr in Curriers neuesten Skulpturen von 2005. Verführerische Flächen spiegeln eine Palette hellerer Farben wie Elfenbein, Schiefergrün, Terrakotta, Granit, Sandstein und Horn-blende (ein Mineral, das in den Farben Grün, Braun und Schwarz vorkommt) wider. *Angelica* (s. Abb. 60) erinnert an einige geneigte Ebenen von *Belmont*, zeigt aber keine menschlichen Proportionen mehr. Zwar erweckt die Skulptur die Vorstellung von den monumentalen, antiken Figuren der Kykladen (3000 – 2000 v. Chr.), die Kantigkeit ihrer dreieckigen Platte lässt sie jedoch weniger gegenständlich wirken. Die einzigartige Reinheit der sich sanft wölbenden, natürlich-exakt angepassten, organischen, aber gleichzeitig eruptiven Formen von Curriers jüngstem Werk fassen die Fortschritte, die sie sowohl technisch als auch konzeptionell gemacht hat, zusammen. Jede Perspektive bietet eine Klarheit, die sich nur dann ergibt, wenn man ihre Wand-Arbeiten von einer Seite zur anderen betrachtet oder ihre frei stehenden Stücke umrundet. Die Namen der Objekte beziehen sich auf Städte, können aber mehrere Bedeutungen haben, was Marcel Proust, der die Vorstellung von „Ortsnamen" in *A la recherche du temps perdu* (deutsch: *Auf der Suche nach der verlorenen Zeit*) eingeführt hatte, erfreut hätte. *Shongo* (s. Abb. 62) bezieht sich beispielsweise gleichzeitig auf eine Stadt in Allegany County, einen afrikanischen Gott des Feuers (der sich entsprechend auf das Feuer des Brennofens bezieht) und auf eine mathematische Netztheorie, abgeleitet von Spielen aus dem Kongo, bei denen man Muster neu zeichnen muss, ohne nochmals dieselbe Linie zu zeichnen oder den Stift abzusetzen (und manchmal gibt es hier mehr als eine Lösung). Das beständige Wesen von Anne Curriers ausbalancierten Skulpturen führt uns zurück zur der Ausgangsidee, dass diese Yin und Yang enthalten, die konzentrierten Wesenheiten der Welt. Ihr außerordentliches Werk betont Raum mit einem Verständnis von menschlicher Vitalität, während es individuell mit der Kürze einer Sprache von Licht, Schatten, Fläche und Masse spricht.

[1] Anne Currier in einem Interview mit Nancy Weekly vom 7. September 2005.

[2] Die Borromäischen Ringe oder Knoten treten in der Kunst verschiedener Kulturen in Erscheinung. Jacques Lacan illustrierte anhand ihrer seine Theorie.

[3,4,5,6] Interview, 7. September 2005.

Cadiz: The Sculptural Topology of Anne Currier's Work
by Mary Drach McInnes

Anne Currier creates modernist objects that engage – and tantalizingly evade – the vocabulary of ceramics and sculpture. Her combination of these territories, areas that have largely been separate for the last century, is intriguing.[1] In terms of materiality, surface structure, and construction these works participate in both the history of ceramics and the modernist canon. Yet Currier's recent work also resides outside these boundaries. Cadiz 2005 (see ill. 70) is emblematic of this new body; it offers us a geometry that is seen more often in mathematical modeling than in contemporary art. Its complexity of folded and enfolded shapes presents us with a sculptural topology that eludes easy apprehension.[2]

Cadiz contains shapes that we cannot conceptually predict or visually anticipate. Formally, the work speaks the language of both ceramics and sculpture. The work is dominated by a series of oblique planes punctuated by smaller spatial envelopes that emerge and wrap around the core. This plasticity evokes the material rhetoric of ceramics, yet the manner in which it molds space distinguishes it as sculpture. Cadiz's surface also positions the work within both fields. Its distinctive matte finish – a granular texture that absorbs the light and attracts the hand – implies both clay body and cut stone. Further, its rich, monochromatic color – applied with sponge and spray – suggests both glaze and stone. The dual-identity of this work is clearly manifested in its construction.

"Fabrication" is the word most closely approximating Currier's technique. The artist avoids the traditional sculptural methods of modeling or carving. Rather, her pieces are cubist-inspired; they are constructed objects of conical and cylindrical shapes that are cut and assembled. However, the actual forming of the work is indebted to pottery-making. Continually throughout her fabrication process, Currier manipulates both the interior and exterior walls – her hands moving in, out, and elliptically around the object. As she progresses into a given work, Currier rotates the form repeatedly. In doing so, a complex, physical geometry unfolds.

Cadiz contains a non-Euclidian geometry of arranged shapes that defies easy observation. Viewing Cadiz is a startling venture. Initially, we see a triangular form rising from the ground; then, it shifts back and aligns with a diagonal plane that reverses direction away from us. As we move towards and around the piece, we view a large folded envelope of mass aggressively pushing forward, which retreats to a broad, oblique surface that then proceeds to wrap back around the form. Currier accentuates the interplay of formal elements. The intersections of surfaces are never perpendicular, but are slanted and splayed. Each constituent part then interconnects, flexes and contracts across the surface. This animation is central to our viewing. For Currier, "the shapes are the players, intersecting, extending, colliding, or passing through / over / under / beyond one another to command space."[3]

There is an extraordinary mobility found in Cadiz. This surface movement lacks the rupture and fragmentation of Currier's earlier work; instead, Cadiz exhibits a sweeping, roving geometry. The broad movement across the surface reminds one of Frank Gehry's recent architectural facades that undulate in a continuous, mobile fabric.[4] Similarly, Currier moves away from the fractured vocabulary of cubist assemblage towards a unified sculptural envelope.[5] With Cadiz, we participate in a rhythmic oscillation over the surface. Our eye moves swiftly back, across, over, and around the piece. We see one view, then another, and another view – all the while remembering the previous views and trying to anticipate the next. This continual play makes Cadiz and its siblings deeply engaging works. Currier creates in these new pieces the sculptural experience that artist Barbara Hepworth once described as "the encircling interplay and dance ... between the object and human sensibility."[6]

Cadiz: die plastische Topologie von Anne Curriers Werk
von Mary Drach McInnes

Anne Currier erschafft modernistische Objekte, die sich des Vokabulars von Keramik und Skulptur bedienen, sich diesem aber gleichzeitig immer wieder auf aufreizende Weise entziehen. Ihre Verknüpfung dieser beiden Bereiche – Bereiche, die im letzten Jahrhundert größtenteils getrennt waren – ist faszinierend.[1] Was Materialität, Oberflächenstruktur und die Konstruktion dieser Arbeiten angeht, so sind sie sowohl Teil der Keramikgeschichte als auch des modernistischen Kanons. Curriers jüngste Arbeiten befinden sich jedoch außerhalb dieser Grenzen. Cadiz 2005 (s. Abb. 70) ist dafür ein Sinnbild; es weist eine Geometrie auf, die man eher von mathematischen Modellen als von zeitgenössischer Kunst kennt. Die Komplexität dieses Werkes mit seinen gefalteten und eingehüllten Formen konfrontiert uns mit einer plastischen Topologie, die nicht einfach zu verstehen ist.[2]

Cadiz besteht aus Formen, die wir weder konzeptionell vorhersagen noch visuell erahnen können. Formal spricht diese Arbeit sowohl die Sprache der Keramik als auch die der Skulptur. Sie wird beherrscht von einer Reihe schiefer Ebenen, die durch kleinere räumliche Hüllen unterbrochen werden, welche aus dem Kernstück heraustreten und dieses umschlingen. Diese Plastizität beschwört die materielle Rhetorik der Keramik herauf. Doch die Art und Weise, wie dieses Werk Raum formt, weist es als Skulptur aus. Auch die Oberfläche von Cadiz – eine körnige Textur, die Licht absorbiert und im Betrachter das Verlangen auslöst, sie zu berühren – positioniert diese Arbeit innerhalb beider Bereiche, indem sie sowohl Tonmasse als auch behauenen Stein impliziert. Darüber hinaus suggeriert die kräftige, monochromatische Farbe, die mit Schwamm und Sprühdose aufgetragen wurde, sowohl Glasur als auch Stein. Die Doppelidentität dieser Arbeit wird besonders deutlich in ihrer Konstruktion.

„Fabrikation" ist das Wort, das Curriers Technik am ehesten beschreibt. Die Künstlerin vermeidet die traditionellen Bildhauertechniken wie Modellieren oder Meißeln. Stattdessen sind ihre Stücke kubistisch inspiriert; sie sind konstruierte Objekte aus konischen und zylindrischen Formen, die aus geschnittenen Tonplatten zusammengebaut werden. Das eigentliche Formen der Arbeit ist jedoch der Töpferei verpflichtet. Während des gesamten Fabrikationsprozesses bearbeitet Currier sowohl die inneren als auch die äußeren Wände manuell – ihre Hände bewegen sich innerhalb und außerhalb elliptisch um das Objekt. Während sie an einem bestimmten Stück weiterarbeitet, dreht Currier die Form immer wieder. Auf diese Weise entfaltet sich eine komplexe Geometrie.

Cadiz bedient sich einer nichteuklidischen Geometrie arrangierter Formen, die den Betrachter dazu zwingt, genau hinzusehen. Cadiz zu betrachten ist ein überraschendes Abenteuer. Zunächst sehen wir eine dreiseitige Form, die sich vom Boden erhebt; dann schiebt sich diese Form zurück und richtet sich nach einer diagonalen Ebene aus, welche sich zurück, von uns weg, bewegt. Wenn wir uns auf das Stück zu und um dieses herum bewegen, sehen wir eine große, gefaltete Hülle aus Masse, die aggressiv nach vorne drängt, sich dann aber auf eine breite, schiefe Ebene zurückzieht, die sich wiederum um die Form wickelt. Currier betont das Wechselspiel formaler Elemente. Die Kanten und Verbindungsstellen dieser Elemente sind nie senkrecht zueinander, sondern abgeschrägt, schief oder gespreizt. Die einzelnen Bestandteile verbinden sich untereinander, biegen sich und ziehen sich über die Oberfläche hinweg zusammen. Diese Bewegung ist essentiell für unsere Wahrnehmung. Currier selbst meint dazu: „Die Formen sind die Akteure: sie kreuzen sich, dehnen sich aus, kollidieren oder laufen durch-, über-, unter- und nebeneinander und beherrschen so den Raum."[3]

Cadiz weist eine außergewöhnliche Beweglichkeit auf. Dieser Oberflächenbewegung ist nicht der Bruch und die Fragmentierung von Curriers früheren Arbeiten eigen; stattdessen besitzt Cadiz eine schwungvolle, wandernde Geometrie. Die breite Bewegung über die Oberfläche erinnert an Frank Gehrys

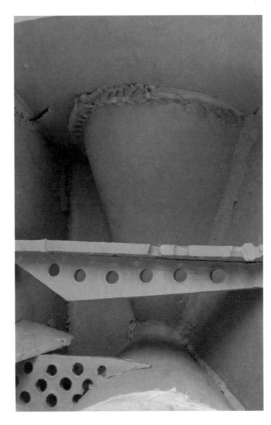

Cadiz

Two different views
See ill. 70

Zwei verschiedene Ansichten
Siehe Abb. 70

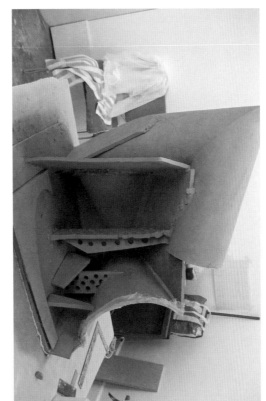

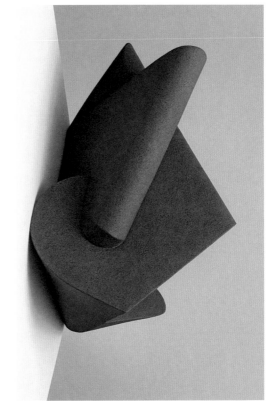

Contraction

Interior views of the work under construction
See ill. 48

Innenansicht des entstehenden Werkes
Siehe Abb. 48

neue architektonische Fassaden, die in einer ununterbrochenen, beweglichen Materialstruktur wellenförmig verlaufen.[4] In ähnlicher Weise entfernt sich Currier vom zersplitterten Vokabular einer kubistischen Ansammlung hin zu einer einheitlichen plastischen Hülle.[5] Cadiz lässt uns rhythmisch über die Oberfläche schwingen. Unser Auge bewegt sich schnell zurück, quer durch, über und um das Stück. Wir sehen eine Ansicht, dann noch eine und noch eine – während wir uns die ganze Zeit an die vorigen Ansichten erinnern und versuchen, die nächsten vorwegzunehmen. Dieses fortwährende Spiel macht Cadiz und seine Artverwandten zu ungemein faszinierenden Werken. Currier erschafft in diesen neuen Stücken die plastische Erfahrung, die die Künstlerin Barbara Hepworth einst als „das einkreisende Wechselspiel ... zwischen dem Objekt und dem menschlichen Empfindungsvermögen" beschrieben hat.[6]

[1] Der Einsatz von Keramik im skulpturalen Bereich fiel im frühen 20. Jahrhundert aufgrund verschiedener Ursachen in Ungnade. Zu diesen Ursachen gehörten sowohl die Kritik der Massenproduktion sowie von Rodins Atelier-Praxis als auch die anschließende Entwicklung der „materialgetreuen" Bewegung. Vgl. Penelope Curtis, Sculpture: 1900–1945 (Oxford: Oxford University Press, 1999), Kapitel 3.

[2] Topologie, einer der aktivsten Bereiche der derzeitigen mathematischen Forschung, gehört zur Transformationsgeometrie. Die Topologie beschäftigt sich u.a. mit der Untersuchung geometrischer Eigenschaften, die sich nicht verändern, wenn Figuren durch Biegen, Dehnen oder Formen verformt werden. Vgl. „Geometry," World Book Multimedia Encyclopedia (Chicago, IL: World Book Encyclopedia, 2005). CD-ROM.

[3] Anne Currier, „Die Künstlerin zu ihrem Werk", s. Appendix, S. 106.

[4] Ich bin Rafael Moneos Untersuchung zeitgenössischer Architektur, insbesondere seinem Kapitel zu Frank Gehry, zu Dank verpflichtet. Vgl. Rafael Moneo, Theoretical Anxiety and Design Strategies In the Work of Eight Contemporary Architects (Cambridge, MA: MIT P, 2004).

[5] Gegenwärtig arbeitet Currier daran, diese Vereinheitlichung der Oberfläche zu steigern. Darüber hinaus experimentiert sie in ihrem akademischen Sabbatjahr mit verschiedenen Tonmassen mit dem Ziel, das Glasieren zukünftiger Arbeiten möglicherweise unnötig zu machen. Anne Currier, persönliches Gespräch, Juni 2006.

[6] Alex Potts, The Sculptural Imagination: Figurative, Modernist, Minimalist (New Haven: Yale UP, 2000), S. 158.

[1] The use of ceramics in sculpture drastically fell out of favor in the early 20th century due to several factors, including the critique of both mass-production and Rodin's studio practice, and the subsequent development of the "truth to materials" movement. See: Penelope Curtis, Sculpture: 1900–1945 (Oxford: Oxford University Press, 1999), Chapter 3.

[2] Topology, one of the most active areas of current mathematical research, is a type of transformational geometry. It has been defined as involving "the study of geometric properties that do not change when figures are deformed by bending, stretching, or molding." See: "Geometry," World Book Multimedia Encyclopedia (Chicago, IL: World Book Encyclopedia, 2005). CD-ROM.

[3] Anne Currier, "Artist Statement," 2006, see appendix, p. 106.

[4] I am indebted to Rafael Moneo's recent discussion of contemporary architecture, especially his chapter on Frank Gehry. See: Rafael Moneo, Theoretical Anxiety and Design Strategies In the Work of Eight Contemporary Architects (Cambridge, MA: MIT P, 2004).

[5] Currier is currently embarking on a project to enhance this unification of surface and is experimenting with different clay bodies during her academic sabbatical to potentially eliminate glazing in future work. Anne Currier, personal interview, June 2006.

[6] Alex Potts, The Sculptural Imagination: Figurative, Modernist, Minimalist (New Haven: Yale UP, 2000), p. 158.

Mental Travel Time
by Helen Williams Drutt English

"It is not the literal past that rules us ... it is images of the past."
George Steiner, *In Bluebeard's Castle*, 1971

The village of Alfred[1] was created in the early nineteenth century. By 1836, the first frame house had become a select school, which eventually evolved into the New York School of Clay Modeling in 1900. Alfred is small, with rows of stores and restaurants not unlike those in middle-class American towns of the mid-twentieth century; it is almost as if time has stopped. The center of town borders on Alfred University's sophisticated campus, where Anne Currier teaches ceramics. From there to route 244, you drive until the asphalt road becomes dirt, the houses disappear, the open countryside enfolds, and you enter Scio, the town where Anne Currier lives. After several miles, on your right, close to the road, is her wood frame house, built around 1850, and her contemporary studio. She came there, after a decade in Colorado, with her husband, George Hrycun, in January 1985. In a letter from July 16,1985, she writes that they found their home: "87 acres and 3 bedrooms! – wonderful house – studio needs work – Love, Anne."

Memory has always been central to my life, as I recall events, meetings, conversations, and letters that unlock the past and bring back so many of the people who have helped shape my life. Mental travel time allows you to recapture your life and move into the past as you remain seated in the present.[2] When and where did Anne Currier enter into my consciousness?

1973: "Another Cup Show" was one of the first national exhibitions that I organized. It included artists working in clay and glass who were invited to submit cups. A cast-porcelain cup encased in a bulbous mold arrived from Anne Currier. I was quite dazzled because the University of Washington's Department of Fire Arts (affectionate term for the ceramic department), Seattle, brought to mind works that incorporated compulsive imagery – like the ceramics of Mark Burns, Nancy Carman, Howard Kottler, Michael Lucero, and Patti Warashina. How did her geometric abstract aesthetic survive there? Now that I think about it, it is Anne's persistence that prevailed – her unwillingness to move from her creative position held in the midst of narrative fury.

In my time capsule, I began to think about the paintings made by her mother, Mary Ann Currier, an established artist. There may be no direct influence; however, Mary Ann's oversize still-life paintings exhibited controlled settings of fruit and objects in space, velvet color, and carefully applied shapes within designated lines. The works incorporate natural forms not unlike those volumes that Anne achieves in her geometric constructions of intertwining soft limbs, especially in the hard-pastel drawings on board. Anne's structured persona also reflects her father Lionel's interest in math and in creating blueprints with great skill, despite the fact that Anne is also a strong Southern lady who has "moved geometric forms into undulated discoveries as the application of color and texture has moved beyond architectonic vessel forms."[3] Anne Currier is enthralled with the power and romance of language; she translates her feelings, desires, and observations into words that merge her creative world with the panoply of thoughts that stream through her existence. Language does that! Anne bestows names upon her work and gives words to her feelings. Her persistence in language is as steady as her need to push firmly to the edge not just her work and teaching manner but her personality.

Titles, therefore, are important to Anne; the lexicon extends our perception of her work. We are grateful that the dictionary is a tool that benefits her understanding and expands our knowledge of her art. The following was received before her exhibition held March 2–30, 1985, at my eponymous gallery in Philadelphia.

February 17, 1984: In a letter from Anne Currier to Helen Drutt, in reference to her sculpture for a forthcoming exhibition at the gallery. Anne cites the titles

Eine Reise in die Erinnerung
von Helen Williams Drutt English

„Nicht die eigentliche Vergangenheit beherrscht uns ..., sondern Bilder der Vergangenheit." George Steiner, *In Blaubarts Burg*, 1971

Das Dorf Alfred[1] entstand im frühen 19. Jahrhundert. Das erste Fachwerkhaus war bereits 1836 eine hervorragende Schule, aus der im Jahre 1900 schließlich die New York School of Clay Modeling (New Yorker Schule für Tonmodellierung) hervorging. Alfred ist klein und voller Laden- und Restaurantzeilen, die denen amerikanischer Mittelklassestädte aus der Mitte des 20. Jahrhunderts ähneln; fast meint man, die Zeit sei hier stehen geblieben. Das Stadtzentrum grenzt an den modernen Campus der Universität Alfred, an der Anne Currier Keramik lehrt. Wenn man von dort bis zur Straße 244 fährt, wird der Asphalt zu Schmutz, die Häuser verschwinden, die offene Landschaft breitet sich vor einem aus und man gelangt nach Scio, der Stadt, in der Anne Currier lebt. Nach einigen Meilen tauchen rechts, nahe der Straße, ihr hölzernes Fachwerkhaus, das um 1850 gebaut wurde, sowie ihr derzeitiges Atelier auf. Nach einem Jahrzehnt in Colorado zog sie im Januar 1985 mit ihrem Mann George Hrycun hierher. In einem Brief vom 16. Juli 1985 schreibt sie, dass sie ihr Zuhause gefunden hätten: „35 Hektar Land und 3 Schlafzimmer! – ein wunderbares Haus – das Atelier braucht Arbeit – In Liebe, Anne."

Die Erinnerung war immer ein zentraler Aspekt meines Lebens. Ich erinnere mich an Ereignisse, Treffen, Gespräche und Briefe, die mir das Tor zur Vergangenheit öffnen und so viele der Menschen zurückbringen, die mein Leben steuerte eine gegossene Porzellantasse bei, die von einer zwiebelartigen Form umgeben war. Ich war ziemlich überwältigt, war die Abteilung für Feuerkünste entscheidend beeinflusst haben. Eine Reise in die Erinnerung erlaubt einem, sein Leben zu rekapitulieren und sich in die Vergangenheit hinein zu bewegen, während man doch fest in der Gegenwart verankert bleibt.[2] Wo und wann trat Anne Currier in mein Bewusstsein?

1973: „Another Cup Show" war eine der ersten landesweiten Ausstellungen, die ich organisierte. Unter anderem waren Künstler, die in Ton oder Glas arbeiteten, dazu eingeladen, Tassen und Schalen einzureichen. Anne Currier jedoch kontrollierte Anordnungen von Obst und Objekten im Raum sowie (wie die Keramikabteilung liebevoll genannt wurde) der Universität Washington doch eher für Werke bekannt, die obligatorisch Bildsymbolik enthielten – wie die Keramiken von Mark Burns, Nancy Carman, Howard Kottler, Michael Lucero und Patti Warashina. Wie nur überlebte ihre geometrische, abstrakte Ästhetik an solch einem Ort? Jetzt, wo ich darüber nachdenke, gelange ich zu dem Schluss, dass es Annes Ausdauer und Beharrlichkeit waren, die sich durchsetzten – ihr Widerwille, von ihrer kreativen Position inmitten von narrativer Wut abzurücken.

In meiner Zeitkapsel kommen mir die Gemälde ihrer Mutter Mary Ann Currier, einer etablierten Künstlerin, in den Sinn. Vielleicht gibt es hier keinen direkten Einfluss; Mary Anns überdimensionale Gemälde von Stillleben zeigten samtene Farben und sorgfältig aufgetragene Formen innerhalb ausgewiesener Linien. Die Arbeiten enthalten natürliche Formen, die durchaus an diejenigen Volumen erinnern, die Anne, die älteste von drei Töchtern, in ihren geometrischen Konstruktionen von ineinander greifenden, weichen Gliedmaßen schafft, insbesondere in den Hartpastellzeichnungen auf Karton. Darüber hinaus finden sich in Annes strukturierter Persönlichkeit Spuren des Interesses ihres Vaters an Mathematik und an Planentwürfen. Davon abgesehen ist Anne auch eine starke Südstaatenlady, die „neue geometrische Formen so schafft, wie der Auftrag von Farbe und Textur über architektonische Gefäßformen hinausgeht".[3]

Anne Currier ist verzaubert von der Macht und der Romantik der Sprache; sie drückt ihre Gefühle, Wünsche und Beobachtungen in Worten aus, die ihre kreative Welt mit den Gedanken verbinden, die durch ihre Existenz strömen. Dergleichen schafft nur die Sprache! Anne gibt ihren Werken Namen und ihren

Gefühlten Worte. Ihr Beharren auf Sprache ist so beständig wie ihr Bedürfnis, nicht nur die Grenzen ihres Werks und ihrer Unterrichtsmethode, sondern auch ihrer Persönlichkeit auszuloten. Werktitel sind deshalb besonders wichtig für Anne; Worte erweitern unsere Wahrnehmung ihrer Arbeit. Wir sind dafür dankbar, dass das Wörterbuch ein Werkzeug ist, dass ihrem eigenen Verständnis ihrer Kunst zugute kommt und unser Wissen über diese Kunst erweitert. Folgendes erhielt ich vor ihrer Ausstellung, die vom 2. bis 30. März 1985 in meiner Galerie in Philadelphia stattfand:

17. Februar 1984 – In einem Brief an Helen Drutt, der sich auf ihre Skulpturen für eine bevorstehende Ausstellung in der Galerie bezieht, nennt Anne die Namen ihrer einzelnen Werke: „Hier ein kleines Blatt mit Erläuterungen – ich habe das ganze Wochenende mit einem Wörterbuch verbracht und darüber nachgedacht, wie ich diese Dinge nennen könnte! „Tertium Quid – etwas, das auf eine bestimmte Art und Weise mit zwei Dingen verwandt, aber von beiden verschieden ist; etwas, das zwischen zwei Dingen liegt." „Terraqueous Rotator – ist die Erde, die zwischen Erde (Land) und Wasser rotiert". „Elliptical Reel – wirbelnde, wogende Ellipsen. „Terr-A-QUA-SI – Kauderwelsch-Wort, das sich aus ‚Terra', ‚Acqua' und ‚quasi' zusammensetzt. „GIRMIZI – als ich unter dem Wort ‚crimson' (karmesinrot) nachschaute, um dieses Stück zu beschreiben, fand ich bei den etymologischen Angaben ‚arabisch': m. Girmizi – archaisch'. „For George – das Lieblingsstück meines Mannes" – (romantischerweise ihrem Ehemann George Hyrcun gewidmet). Und weiterhin spielen Werktitel eine große Rolle: Cucumflexor, 1988–1990: Namen von Pastellzeichnungen auf hartem Karton. (Die Zeichnungen beinhalten verblüffende und schwunghafte Bewegungen.)

27. Januar 1991 – „Infundibulum, Cylindrical diplex und Konostoma sind die Arbeiten … für die 14-Jahres-Show. Horizontal Sequent (pk) befindet sich hier in meinem Haus und Horizontal Sequent (gr) ist eines der verpackten Stücke in New York City … schick diese nach Philadelphia. Inversion und Brody."

1992–2006 – Eine Auswahl von Werktiteln aus der Vergangenheit: Rollway (1992), Angulated Still Life (1992), Distraction (1996), Fault (1996), Eleusis (1999), Dipolar Association (1999), Zoar (2000), Ricochet (2001), First of June (2002), Vorticella (2005) und Cloven (2006).

Ihr Briefstil ist von großer visueller Schönheit – eine kursive Schrift in weit ausholenden Tintenstrichen auf einfarbigem Papier, linierte Karten in den Maßen 13 x 18 cm sowie Postkarten von ihren Reisen oder Workshops. Als in den 1980er Jahren das Faxzeitalter anbrach, wurde das Faxpapier der Universität Alfred zu einem vertrauten Mittel der Korrespondenz. Auch mit dem Auftauchen von E-Mails ging ihre Leidenschaft für das Schreiben nicht verloren. Neben dem Computer entdeckte sie um 2001/2 die Digitalkamera. Diese bot ihr die Möglichkeit, persönliches Briefpapier herzustellen. Worte des Mitgefühls, Worte der Verehrung, Landschaftsbeschreibungen, biografische Dokumentationen, Ansichten des Ateliers sowie ihres geliebten Hundes Iris, scharfe Erinnerungen daran, dass sie Aufmerksamkeit und Respekt benötige und dass ihre Arbeit großartig sei. Ihre Briefe berichten ausführlich über ihre sowohl privaten als auch allgemein bekannten Pläne und bestätigen immer wieder ihre über alles stehende Hingabe an ihr Atelier und ihren Einsatz für ihre Studenten. Oft erhielt ich Briefe mit Klebebildern, welche die Adresse besonders hervorhoben, auf ihre Gedanken hinwiesen oder aber einem Feiertag zu Ehren angebracht worden waren – z.B. in der Form von Schmetterlingen, Süßigkeiten, Kürbissen, Hexen oder Elvis. Ein andermal war eine schwarze Katze aufgeklebt, aus der ein Wasch-zettel herauskam, der um Auskunft bat. Vor drei Jahren erhielt ich ein Blatt Papier voller Teekannen, das die Überdosis an Teekannenausstellungen beklagte; aber der Umschlag mit einer Collage aus Klebebildern, die ein prächtiges, an Chardin erinnerndes Stillleben bildeten, war zweifellos beispielhaft. Ist es möglich, dass Howard Kottlers[4] Vermächtnis und Leidenschaft für Abziehbilder in Annes Briefen wiedergeboren wurde?

Mein Archiv ihrer Briefe an mich enthält Gedanken, die mich mit ihrem Denken und ihrem täglichen Leben verbinden. Durch Zitate und Erklärungen

for individual works. "Here's a little definition sheet – I spent all weekend with a dictionary deliberating what to call these things!" "Tertium Quid – something related in some way to two things but distinct from both; something intermediate between both." "Terraqueous Rotator – is the earth rotating between earth (land) and water." "Elliptical Reel – whirling waving ellipses." "Terr-A-QUA-SI – mumbo-jumbo word combining Terra, Aqua, and Quasi." "GIRMIZI – I was looking under the word 'crimson' to define/describe this piece and in the etymology was Ar: m.Girmizi – archaic." "For George – my husband's favorite piece" – (Romantically dedicated to George Hrycun, her husband). Her titles continue: Circumflexor, 1988–1990: Titles from pastel drawings on hard board. (The drawings incorporate amazing movement which illustrates broad sweeps of ribbonlike furls.)

January 27, 1991 – "Infundibulum, Cylindrical Diplex, and Konostoma are the pieces … for the 14-year show. Horizontal Sequent (pk) is here at my house and Horizontal Sequent (gr) is one of the boxed pieces in N.Y.C. … send to Philadelphia. Inversion and Brody Slide."

1992–2006 – Past titles include: Rollway (1992), Angulated Still Life (1992), Distraction (1996), Fault (1996), Eleusis (1999), Dipolar Association (1999), Zoar (2000), Ricochet (2001), First of June (2002), Vorticella (2005), and Cloven (2006).

Her epistolary style is visually beautiful – a cursive script in broad ink strokes on plain paper, 5x7 lined cards, and postcards from her journeys or workshops. In the eighties, as we entered the age of facsimile, Alfred University's fax paper became a familiar vehicle for correspondence. Her passion for writing was lost with e-mail, however; in addition to the computer, she discovered the digital camera in 2001–2, which provided her with the ability to make personal note-papers. Words of compassion, words of venery, descriptions of landscape, bio-graphical documentation, views of the studio as well as her beloved dog, Iris, sharp reminders that she requires attention and respect and that her work is great. Letters detail her plans, both private and public, and always confirm her dedication to her studio and students above all else. Often letters arrived with decals accenting the address or "pointing" to her thoughts, or honoring a holiday – butterflies, candy corn, pumpkins, witches, Elvis – or a black cat with a blurb coming forth from its image requesting information. Three years ago, a sheet of teapots arrived citing the overdose of teapot exhibitions; but the envelope, without a doubt, with a decoupage of decals forming a magnificent Chardin-like still life was exemplary. Is it possible that Howard Kottler's[4] legacy and passion for decals has been reborn in Anne's letters?

My archive of her letters to me contains thoughts that bind me to her thinking and daily life. Through the quotes and statements, a lively view of Anne Currier is achieved that connects me with her work but also takes me into her lively verbose self. The words communicate her changing moods and unedited responses.

February 2, 1982 – "There are new things happening that I find visually and intellectually exciting and challenging – I just need to learn the vocabulary for exploring new forms and their fabrication. My middle finger bears the calluses of rubbing but worth the pain."

July 17, 1983 – "I was in the backyard being vibrated by an oscillating sander – refinishing some chairs."

March 26, 1984 Louisville, Kentucky – "If the next 2 kiln firings go well (Hail Mary!), you will be receiving some very 'hot' pieces – I'm not bragging, I just know!"

April 9, 1984 – "The two pieces that I spoke of in my last letter came out great – in my estimation anyway! I trust you'll find your patience in waiting to be worthwhile."

May 4, 1987 – "Cupreous Resorption is NFS – primarily because I want to keep it in my collection – for my family." (However, it was eventually sold to a private collection.)

February 11, 1988 – "I'm excited about the new work. I think it's good – clean and definite."

November 20, 1988 – "Enclosed are the most recently completed and photo-documented drawings. Pardon my criticism – but I do think I'm getting better with them."

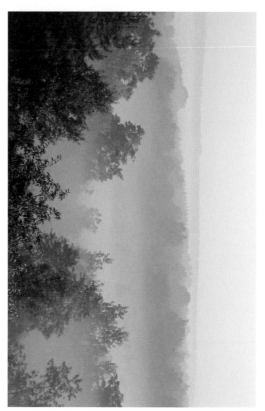

March 4, 1991 – "It was good to hear from you last night. After you called I had to go down to the studio – lantern in hand – to stoke the stove down there so my clay wouldn't freeze. Still no electricity this a.m. No electricity in Alfred. ... Of course today the sun is out – really quite beautiful – above freezing and everything is melting fast. Now we just have to watch out for huge ice chunks falling on our heads!"

January 12, 1992 – "I don't want to go to Miami; I want to go to the studio." (Refers to the migration of all artists to the Art Fair.)

March 11, 1993 – "Outta space/outta time. Time to fire up the studio woodstove and get to work."

February 12, 1999 – "I just bought this new fountain pen – I didn't need it, I just wanted it – so now I have to use it! ... The big 'centerfold' and cover article is on Tony Cragg. Boy – between him and Sir Anthony Caro, you'd think no one in the twentieth century ever really touched clay."

March 28, 2000 – "Thank you for your call this a.m. I think you must have amazing upper body strength – all the lives that you support – and like the Timex watch you still keep ticking."

April 19, 2000 – "Interesting to read in the New York Times that Rem Koolhaas won the Pritzker. My itinerary includes visits to some of his buildings. P.S. FYI – at present, I have no plans to go to SOFA: NYC.[5] I have to stay home and try to do some work in the studio."

June 13, 2000 – "We are currently in the midst of a fabulous thunder- and rainstorm – my lights here in the studio are flickering – the rain is torrential! My slabs and cylinders were made last Thursday but still remain as wet as when I made them, due to all the rain and high humidity. All the flowers – poppies, irises, peonies – will be wiped out, I'm afraid."

September 17, 2001 – "I trust that neither of your children was harmed in this most unspeakable and horrific act of terrorism. ... I wanted to attend the Art Alliance opening last week[6] – my teaching schedule made it prohibitive since my classes are Wed.–Fri. Given all the events of the week, it was more important to hold classes and be available to students."

October 22, 2001 – "I hope that the following comes through ok – I have copied the letter that I rec'd from ... the Phillips Museum of Art in Lancaster, Pa. – ...(They) called last week and left a voice message on my machine –...I have no idea who the other nine artists might be but it is of no concern – I want the exposure – and at the moment, the only exhibit for 2002 is the one in May at the Gardiner in Toronto.....So, this is just an FYI for your files – I wish the requests were to purchase the work!!! I need cash for the new studios we plan to build next summer!"

September 14, 2003 – Scans from her sketchbook arrived revealing her linear thoughts which would eventually assume a three dimensional form.

January 10, 2004 – "One comes from a mold – one is a mold – it's brutally cold here – minus 19 degrees this A.M. when we woke." (Images of a hat mold and cake on her photo-framed note paper)

March 22, 2004 e-mail – "I have some pieces in the studio to photograph with the digital and download to send to you. My elves are on strike and have left the planet – i.e., it's just me! Images of finished pieces are on another computer! It will happen – give me a few days, Anne."

March 26, 2004 e-mail – "Regarding the M.A.G. (Memorial Art Gallery, Rochester, New York) exhibition ... For now, here is what is available. I really like all three pieces – Homage is the sibling to Span that was acquired ... from SOFA/Chicago – it was in the Groot booth. OK – off to do some glaze tests for the new work. The maple syrup is flowing! George and I may need to go eat pancakes as a matter of seasonal duty! xoxoxoAnne"

For the past five years, the digital camera has provided Anne with the means to make a visual record of her observations. She captures everything: a leaf on the ground wet with rain; a close-up of the raindrop; an Art Déco countertop in New York; a swan in the pond; a tree in a haze of snow or stark in the cold air after the storm. Images of early rhubarb are soft and succulent and subdued by the surrounding earth, the morning mist over the pond brings to

ergibt sich ein lebendiges Bild von Anne Currier, das mich ihrer Arbeit, aber auch ihrem lebendigen, wortreichen Selbst näher bringt. Die Worte kommunizieren ihre wechselnden Launen und ihre spontanen Reaktionen.

2. Februar 1982 – "Neue Dinge passieren, die ich visuell und intellektuell als faszinierend und herausfordernd empfinde – ich muss nur noch das Vokabular erlernen, um neue Formen und ihre Herstellung zu erforschen. Mein Mittelfinger ist vom leichten Reiben schön voller Hornhaut, aber das ist es wert."

17. Juli 1983 – "Ich war im Garten hinter dem Haus und wurde von einem vibrierenden Sandstrahlgebläse durchgeschüttelt – während ich ein paar Stühle nochmals glättete."

26. März 1984 Louisville, Kentucky – "Wenn die nächsten beiden Brände im Ofen (so Gott will!) gut gehen, wirst Du bald einige sehr 'heiße' Stücke erhalten – ich prahle nicht, ich weiß es einfach!"

9. April 1984 – "Die zwei Arbeiten, von denen ich in meinem letzten Brief sprach, sind großartig geworden – zumindest meiner Einschätzung nach! Ich bin mir sicher, Du wirst Dich für Dein geduldiges Warten belohnt sehen."

4. Mai 1987 – "Cupreous Resorption ist unverkäuflich – vor allem deshalb, weil ich es in meiner Sammlung bewahren will – für meine Familie." (Es wurde jedoch schließlich an eine Privatsammlung verkauft.)

11. Februar 1988 – "Ich bin begeistert von der neuen Arbeit. Ich denke, sie ist gut – klar und genau."

20. November 1988 – "Hier beigefügt sind die neuesten, fertig gestellten und fotografisch dokumentierten Zeichnungen. Entschuldige meine Kritik – aber ich denke, ich werde damit besser."

4. März 1991 – "Es war schön, letzte Nacht von Dir zu hören. Nachdem Du angerufen hattest, musste ich hinunter ins Atelier gehen – die Laterne in der Hand – und den Ofen unten beheizen, damit mein Ton nicht gefriert. Diesen Morgen gibt es immer noch keinen Strom. Keinen Strom in Alfred. ... Natürlich scheint die Sonne heute – das ist tatsächlich ziemlich schön – über das Gefrorene und alles schmilzt schnell. Jetzt müssen wir nur aufpassen, dass uns keine riesigen Eisbrocken auf den Kopf fallen!"

12. Januar 1992 – "Ich möchte nicht nach Miami fahren; ich möchte lieber ins Atelier gehen." (Dies bezieht sich auf die Abwanderung aller Künstler zur Kunstmesse.)

11. März 1993 – "Außerhalb von Zeit und Raum. Jetzt ist die Zeit, den Holzofen im Atelier zu befeuern und sich an die Arbeit zu machen."

12. Februar 1999 – "Ich habe mir gerade diesen neuen Füller gekauft – ich habe ihn nicht wirklich gebraucht, ich wollte ihn einfach – jetzt muss ich ihn auch benutzen! ... Der große 'Ausfalter'-Artikel und die Titelgeschichte sind über Tony Cragg. Junge, Junge – man könnte meinen, außer ihm und Sir Anthony Caro hätte im 20. Jahrhundert niemand jemals wirklich Ton angerührt."

28. März 2000 – "Danke für Deinen Anruf heute Morgen. Du musst wirklich unglaubliche Körperkraft haben – all die Leben, die Du unterstützt –, und wie die Timex-Uhr tickst Du immer weiter."

19. April 2000 – "Interessant, in der New York Times zu lesen, dass Rem Koolhaas den Pritzker-Preis gewonnen hat. Auf meiner Reiseroute werde ich auch einige seiner Gebäude besichtigen. P.S.: Zu Deiner Information – im Moment plane ich nicht, die SOFA[5] in New York zu besuchen. Ich muss zu Hause bleiben und versuchen, in meinem Atelier etwas zu arbeiten."

13. Juni 2000 – "Wir befinden uns gerade inmitten eines fabelhaften Gewitters und Regengusses – die Lichter hier in meinem Atelier flackern – es regnet in Strömen! Meine Platten und Zylinder habe ich letzten Donnerstag gemacht. Aufgrund des ganzen Regens und der hohen Luftfeuchtigkeit sind sie aber immer noch so nass wie zu dem Zeitpunkt, als ich sie gemacht habe. Ich fürchte, die ganzen Blumen – Mohnblumen, Schwertlilien, Pfingstrosen – werden vernichtet."

17. September 2001 – "Ich hoffe, keines Deiner Kinder kam in diesem unaussprechlich entsetzlichen terroristischen Akt zu Schaden. ... Ich wollte die Ausstellungseröffnung der Art Alliance (Kunstbündnis) letzte Woche besuchen[6]

doch mein Lehrplan verbat mir das, unterrichte ich doch von Mittwoch bis Freitag. Angesichts der Ereignisse der Woche war es wichtiger, zu unterrichten und für die Studenten da zu sein."

22. Oktober 2001 – „Ich hoffe, das Folgende kommt gut durch – ich habe den Brief, den ich vom ... Phillips Museum of Art in Lancaster, Pa., erhalten habe, kopiert. ... [Sie] haben letzte Woche angerufen und eine Nachricht auf meinem Anrufbeantworter hinterlassen – ... Ich habe keine Ahnung, wer die anderen neun Künstler sein könnten, aber das spielt keine Rolle – ich will die Ausstellung –, und im Moment ist die einzige für 2002 geplante Ausstellung diejenige im Mai im Gardiner Museum in Toronto. ... Dies nur zu Deiner Information für Deine Akten – ich wünschte, sie wollten die Arbeit kaufen!!! Ich brauche Geld für die neuen Ateliers, die wir nächsten Sommer bauen wollen!"

14. September 2003 – Scans aus ihrem Skizzenbuch treffen ein und offenbaren ihre linearen Gedanken, die schließlich eine dreidimensionale Form annehmen sollten.

10. Januar 2004 – „Eines kommt aus einer Form – eines ist eine Form – es ist hier bitterkalt – minus 28 C diesen Morgen, als wir aufwachten." (Bilder eines Kuchens und einer Hutform auf ihrem von Fotografien umrahmten Briefpapier)

22. März 2004, E-Mail – „Im Atelier sind einige Stücke, die ich noch mit der Digitalkamera fotografieren muss. Dann muss ich die Aufnahmen noch herunterladen, um sie Dir zu schicken. Meine Elfen streiken und haben den Planeten verlassen – das bedeutet, ich bin ganz allein! Bilder von fertigen Arbeiten befinden sich auf einem anderen Computer. Ich schicke Dir alles zu – gib mir noch ein paar Tage. Anne."

26. März 2004, E-Mail – „Was die Ausstellung in der M.A.G. (Memorial Art Gallery, Rochester, New York) betrifft ... hier ist, was für den Moment zur Verfügung steht. Ich mag wirklich alle drei Stücke – Homage ist mit Span verwandt, das ... von SOFA/Chicago erworben wurde – es war am Groot-Stand. OK – muss jetzt los, um einige Glasurversuche für die neue Arbeit zu machen. Der Ahornsirup fließt in Strömen! George und ich müssen wohl Pfannkuchen essen gehen – das ist eine jahreszeitlich bedingte Pflicht! xoxoxo Anne"

Seit fünf Jahren bietet die Digitalkamera Anne die Möglichkeit, ihre Beobachtungen visuell zu dokumentieren. Sie erfasst alles: ein vom Regen durchnässtes Blatt auf dem Boden; eine Nahaufnahme eines Regentropfens; eine Art Déco-Arbeitsplatte in New York; ein Schwan im Teich; ein Baum im Schneegestöber oder ganz kahl in der kalten Luft nach einem Sturm; Bilder zeigen frühen Rhabarber, der weich und saftig erscheint, dessen Wirkung aber durch die umgebende Erde gedämpft wird; der Morgennebel über dem Teich lässt einen an die Farben denken, die Annes Palette sicherlich beeinflussen. All das, was sie sieht, wenn sich Blätter in einem Haufen auf der Erde entfalten, wenn die Eisschicht auf einem gefrorenen Teich in Richtung des Ufers treibt oder ihr Atelier im Frühlingstau, Winter, Sommer oder Herbst, keimende Seidenpflanzenknospen, Gras, laubwechselnde Zweige, George, der von einer Kiefer verdeckt wird – all das ist Teil dieser Bilder, die sich auf einmal in den reichen Grau-, Braun- und Ockertönen wiederfinden, die Annes Palette beim Modellieren und Zeichnen darstellen. Diejenigen unter uns, die Anne kennen, erkennen hier die Jahreszeiten in Scio und Alfred wieder. Diese Fotografien, Beobachtungen ihrer Umgebung, stellen eine weitere Seite von Anne dar, die das Leben ihrer Freunde bereichert. Warum kommt mir in diesem Zusammenhang Robert Arnesons berühmtes Werk Werk Palace at 6 a.m. (Palast um 6 Uhr morgens) in den Sinn? Vielleicht, weil auch er Bilder seines Privatlebens einfängt und sie in seiner Arbeit zelebriert? So finden sich Spuren seiner Fixierung auf Alice, seines Hauses in Davis, Kalifonien, in seinen Gemälden, Zeichnungen oder dreidimensionalen Keramikskulpturen.

Seit über 20 Jahren dauern diese geschriebenen Botschaften und Erklärungen nun an und kennzeichnen eine Beziehung, die nicht nur eine berufliche, sondern auch eine freundschaftliche ist. In einem Brief vom 8. März 1985 schrieb ich: „Das intellektuelle Streben nach organischen und geometrischen Formen ist mit Farbe und überraschender Oberflächenstruktur kombiniert. Die

mind the stretches of color bound to influence Anne's palette. What her eye sees as leaves unfold in a pile on the earth, as a frozen pond streaks its layer of ice toward a shoreline, or her studio at spring thaw, winter, summer, or autumn. Emerging milkweed buds, grass, deciduous twigs, George hidden in the pine, are all part of these images that are at once gathered into the broad sweeps of succulent grays, tans, and ochers that are Anne's palette in the resulting sculpture and drawings. For those of us who know Anne, we have Scio and Alfred in all of its seasons. These photographs, as she observes her environment, are another side of Anne that enhances the lives of her friends. Why do I think of Robert Arneson's famous piece the Palace at 6 a.m.? Perhaps, because he, too, captured images from his personal life and celebrated them in his work. His obsession with Alice, his development house in Davis, California, can be seen in his paintings, drawings, or three-dimensional ceramic sculpture.

The written messages and explanations continue for over twenty years marking a relationship that is not only professional but between friends. In a letter dated March 8, 1985, I wrote that "the intellectual pursuits of organic and geometric forms are combined with color and unexpected textured surface. The drawings seem to intuitively expand the ideas conceived in clay – they are reminiscent of Indian temple structures." The late Stella Kramrisch, whose scholarly writings and exhibitions on Indian Hindu temples and the manifestations of Shiva were world renowned, praised Anne's gentle harmony and similarity of individual shapes. My mental travel time, once again, takes me to a conversation from more than twenty years ago, in which Stella Kramrisch said that Anne's drawings were an abstraction of the intertwining figures in the Indian temple reliefs. Her early statement "Earth's lifeblood streams through the members of the figures and gives them form" could be applied to Anne Currier's reliefs of a decade ago.

Insights into her descriptive vocabulary and understanding of Anne's work continue with her personal statements: "In my cylindrical pieces, I strive to create a sense of the continuousness of forms which are concurrently singular and interdependent as they pass through and around each other, alluding to a logical disruption of orbital and gyroscopic movement and perspective." (Anne Currier, date unknown)

"The ceramic objects are the products of my curiosity and need to experience the physical and visual exchange of masses and voids. Projection and recession, hard and soft, light and shadow, substance and impression are aspects of the works' subject matter, if, in fact, it can actually be given a name. It's an obsessive compulsion to experience inside and outside – moving into and through a space and time – using the simplicity of cylinders, cones, planes and edges. Light and shadow are crucial to the illusion and exchange of recession and projection. The process of working with the clay shapes provides a clarity and occasions to physically being there, at that moment in time, when the material shapes intersect, extend, collide or pass through/over/under one another to create a space. A glazed surface that looks soft and absorbs light yet actually feels like a 120-grit sand paper is part of the interplay." (Anne Currier, 1997, Scio, New York)

Her statements and letters succinctly describe not only her work but her obsessive personality – that desire to experience everything, to move in and out of personal as well as scholarly experiences. She yearns to visit and revisit those works of art that have become her mentors – like Rogier van der Weyden's The Crucifixion, with the Virgin and Saint John and Evangelist Mourning (c. 1450-55) and Raymond Duchamp-Villon's The Horse (1914) "whose combination of organic and mechanical projections and recessions move in space and yet it has areas of mass and power and then areas that are delicate and detailed. Why do I like it? Because I wish I had made it!" Because Anne continues to confront situations that are challenging – with friends, professional peers, and students – the challenges extend daily to her work in the studio. She pushes her imagination to its limits, constantly bringing the natural sphere that surrounds her into the work and shaping architectonic forms

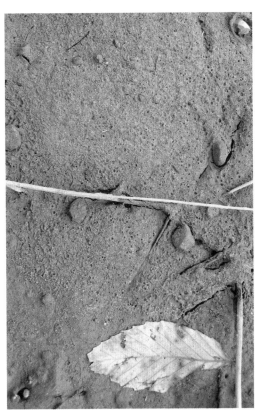

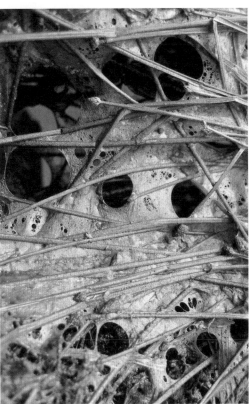

that defy the limits of the method by which they were built. In 1998, a review in the *Philadelphia Inquirer* suggested that "(an) odd mixture of refined elegance and vigorous constructivism is what gives Anne Currier's abstract ceramic sculptures their edge. She cuts across boundaries of shapes to create enigmatic slabs." As a person, she cuts across boundaries of personal behavior, reflected both in her letters as well as her teaching. Indian tradition says, "Everything in *The Mahabharata* is elsewhere, what is not there is nowhere."[7] In the life of Anne Currier, everything is everywhere.[8]

1 Alfred, New York, is located in Upstate New York, USA, 75 miles south of Rochester.

2 Eric R. Kandel, *In Search of Memory* (New York, NY: W.W. Norton & Company, Inc., 2006), p. 3.

3 Note in the Helen Drutt archives, Philadelphia, PA, USA, source unknown.

4 Howard Kottler was a Professor of Ceramics at the University of Washington and well-known as a Decalcomaniac.

5 Sculpture, Objects and Functional Art, a biannual art fair held in Chicago and New York, USA.

6 Reference to September 11, 2001 which coincides with the opening of "Poetics of Clay: An International Perspective" at the Philadelphia Art Alliance, Philadelphia, Pennsylvania, USA.

7 Jean-Claude Carriere, *The Mahabharata* (New York, NY: Harper & Row, 1985), p. xii.

8 Quotes from Anne Currier's letters were drawn from the Helen Drutt archives, Philadelphia, PA, USA.

1 Alfred, New York, befindet sich in Upstate New York, USA, etwa 120 km südlich von Rochester.

2 Vgl. Eric R. Kandel, *In Search of Memory* (New York, NY: W.W. Norton & Company, Inc., 2006), S. 3.

3 Notiz, die sich im Helen Drutt Archiv, Philadelphia, PA, USA, befindet und deren Herkunft unbekannt ist.

4 Howard Kottler war Professor für Keramik an der Universität Washington und wohl bekannt für seine Leidenschaft für Klebebilder.

5 „Sculpture, Objects and Functional Art" („Skulptur, Objekte und funktionelle Kunst"), eine zweimal jährlich – in Chicago und New York – stattfindende Kunstmesse.

6 Dies bezieht sich auf den 11. September 2001, der mit der Eröffnung von „Poetics of Clay: An International Perspective" („Poetik des Tons: eine internationale Perspektive") in der Philadelphia Art Alliance in Philadelphia, Pennsylvania, zusammenfiel.

7 Jean-Claude Carriere, *The Mahabharata* (New York, NY: Harper & Row, 1985), S. xii.

8 Zitate aus Anne Curriers Briefen stammen aus dem Helen Drutt Archiv, Philadelphia, PA, USA.

Zeichnungen scheinen intuitiv die Ideen weiterzuführen, die in Ton ausgedrückt wurden – sie erinnern an indische Tempelstrukturen." Die inzwischen verstorbene Stella Kramisch, deren wissenschaftliche Abhandlungen und Ausstellungen zu indischen Hindu-Tempeln und den Manifestationen von Shiva zu Weltberühmtheit gelangten, rühmte Annes sanfte Harmonie und Ähnlichkeit individueller Formen. Meine Reise in die Erinnerung führt mich noch einmal zu einem Gespräch vor mehr als 20 Jahren, in welchem Stella Kramisch bemerkte, dass Annes Zeichnungen eine Abstraktion sich verflechtender Figuren in Reliefs indischer Tempel seien. Ihre frühe Aussage „der Lebenssaft der Erde fließt durch die Glieder der Figuren und gibt ihnen Form" trifft auch auf Anne Curriers Reliefs des letzten Jahrzehnts zu.

Annes persönliche Erklärungen geben ebenfalls Einsicht in ihr beschreibendes Vokabular und erweitern unser Verständnis ihres Werkes: „In meinen zylindrischen Stücken versuche ich, ein Gefühl der Kontinuität von Formen zu schaffen, die gleichzeitig einzigartig und voneinander abhängig sind, wenn sie durch- und umeinander verlaufen und so auf einen logischen Bruch in der Kreis- und Kreiselbewegung und -perspektive hinweisen." (Anne Currier, Datum nicht bekannt)

„Die keramischen Gegenstände sind die Produkte meiner Neugier und meines Bedürfnisses, den physikalischen und visuellen Austausch von Massen und Hohlräumen zu erleben. Vorstehendes und Zurückweichendes, Licht und Schatten, Substanz und Impression sind Aspekte des Gegenstands meiner Arbeiten, wenn man das tatsächlich benennen kann. Es ist ein Zwang, Innen und Außen zu erfahren, indem ich mich in und durch Zeit und Raum bewege und dabei die Einfachheit von Zylindern, Kegeln, Kanten und Ecken nutze. Licht und Schatten sind von wesentlicher Bedeutung für die Illusion und den Austausch von Vorstehendem und Zurückweichendem. Mit Tonformen zu arbeiten, verschafft Klarheit und Gelegenheit, körperlich zu einem bestimmten Zeitpunkt da zu sein, wenn die stofflichen Formen sich kreuzen, ausdehnen, kollidieren oder durch-, über-, unter- und nebeneinander laufen und den Raum beherrschen. Eine glasierte Oberfläche, die weich aussieht und Licht absorbiert, sich gleichzeitig jedoch wie sehr grobes Sandpapier anfühlt, ist Teil des Wechselspiels." (Anne Currier, 1997, Scio, New York)

Ihre Erklärungen und Briefe beschreiben kurz und bündig nicht nur ihre Arbeit, sondern auch ihre obsessive Persönlichkeit – das Verlangen, alles zu erleben, persönliche wie auch wissenschaftliche Erfahrungen zu machen. Sie sehnt sich danach, immer wieder diejenigen Kunstwerke zu besichtigen, die zu ihren Mentoren wurden – wie z.B. Rogier van der Weydens *Christus am Kreuz zwischen Maria, Johannes und dem Stifterpaar* (ca. 1450–55) und Raymond Duchamp-Villons *Das Pferd* (1914), „dessen Kombination von organischem und mechanischem Vorstehendem und Zurückweichendem sich im Raum bewegt und dennoch sowohl mächtige, massige als auch zarte, detaillierte Stellen hat. Warum ich es mag? Weil ich wünschte, ich hätte es geschaffen!" Da sich Anne weiterhin schwierigen und zugleich faszinierenden Situationen stellt – im Umgang mit Freunden, Kollegen und Studenten –, sieht sie sich täglich bei ihrer Arbeit im Atelier mit Herausforderungen konfrontiert. Sie geht bis an die Grenzen ihrer Phantasie, wobei sie ihre natürliche Umgebung in ihre Arbeit integriert und architektonische Formen schafft, die den Grenzen der Technik trotzen, mit der sie hergestellt werden. 1998 war in einer Rezension des *Philadelphia Inquirer* zu lesen: „(Eine) sonderbare Mischung aus verfeinerter Eleganz und lebhaftem Konstruktivismus verleiht Anne Curriers keramischen Skulpturen ihre Schärfe. Sie überschneidet Formgrenzen, um rätselhafte Platten zu schaffen." Als Mensch überschreitet sie die Grenzen des persönlichen Umgangs, wie sich sowohl in ihren Briefen als auch in ihrer Lehrtätigkeit zeigt. In der indischen Tradition heißt es: „Alles im *Mahabharata* ist anderswo, und was nicht dort ist, ist nirgendwo."[7] In Anne Curriers Leben ist alles überall.[8]

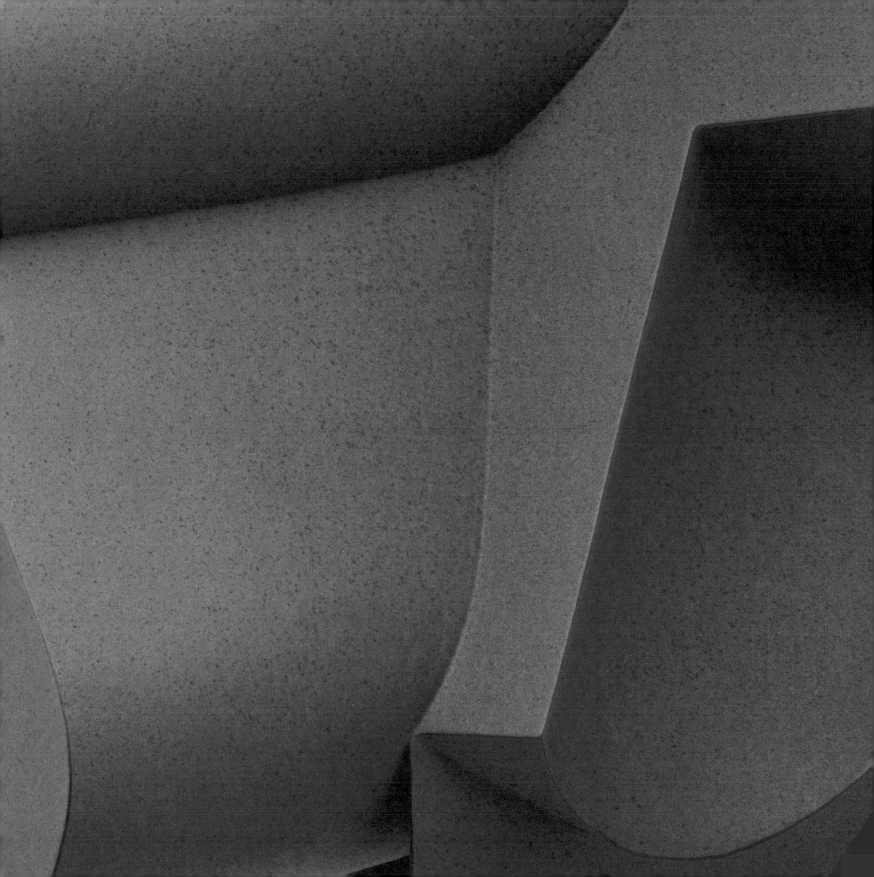

The Work of Anne Currier
from 1987 to 2006

Arbeiten von Anne Currier
1987 bis 2006

Iceberg

1987, glazed ceramic, 11 × 23 × 17 in.
Lois and Herbert Rothenberg, USA

1987, glasierte Keramik, 28 × 58,4 × 43,2 cm
Lois und Herbert Rothenberg, USA

1

Konostoma

1989, glazed ceramic, 15 × 27 × 17 in.
Le Musée des Beaux-Arts de Montréal, Québec,
Canada

1989, glasierte Keramik, 38,1 × 68,6 × 43,2 cm
Le Musée des Beaux-Arts de Montréal,
Quebec, Kanada

2

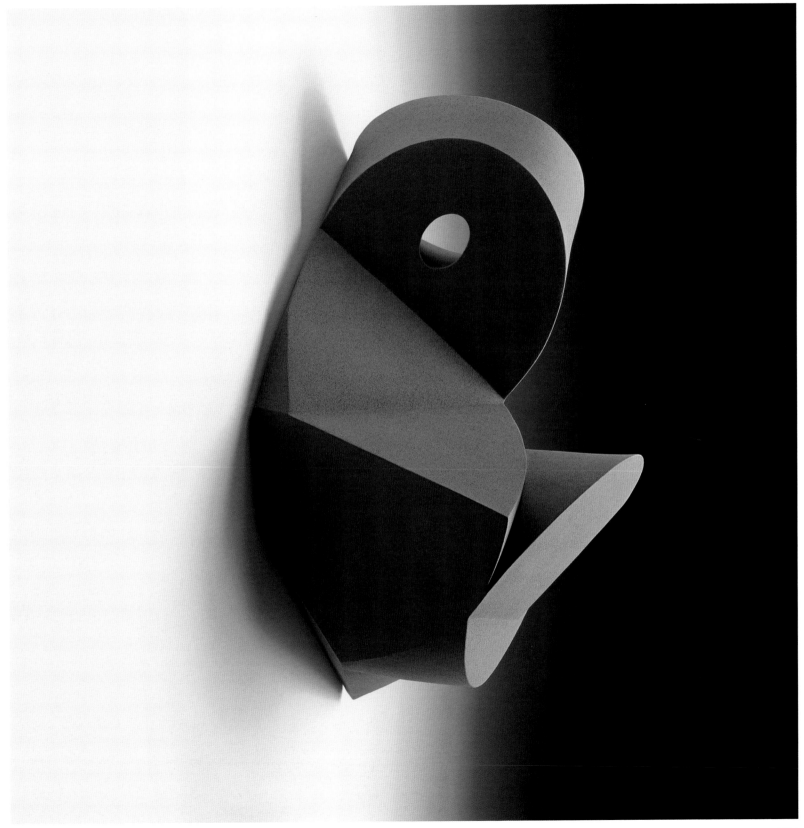

Inversion

1989, glazed ceramic, 18 × 38 × 27 in.
Schein-Joseph International Museum of Ceramic
Art, New York State College of Ceramics at
Alfred University, Alfred, NY, USA

1989, glasierte Keramik, 45,7 × 96,5 × 68,6 cm
Schein-Joseph International Museum of Ceramic
Art, New York State College of Ceramics at
Alfred University, Alfred, NY, USA

3

Vase

Four different views
1989, glazed ceramic, 18 × 10 × 8 in.
Private collection

Vier verschiedene Ansichten
1989, glasierte Keramik, 45,7 × 25,4 × 20,3 cm
Privatsammlung

4

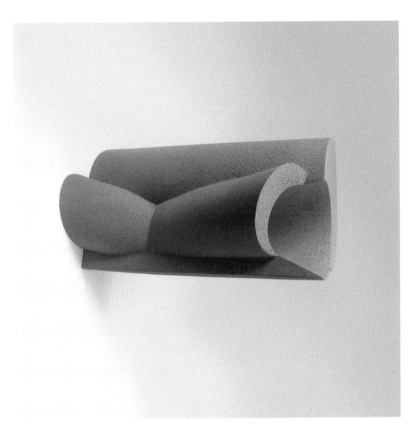

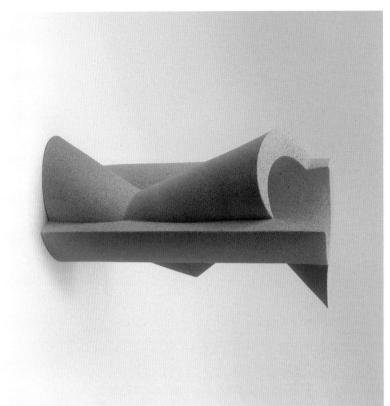

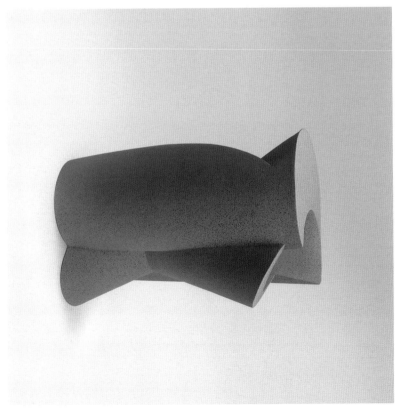

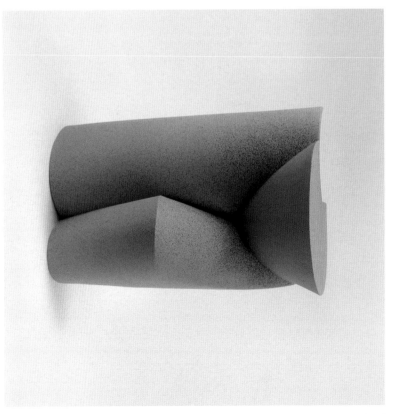

Cylindrical Diplex

1989, glazed ceramic, 11 × 41 × 17 in.
Collection of the artist

1989, glasierte Keramik, 28 × 104,1 × 43,2 cm
Sammlung der Künstlerin

5

Hryno, SM

1989, glazed ceramic, 11 × 34 × 18 in.
Collection of the artist

1989, glasierte Keramik, 27,9 × 86,4 × 45,7 cm
Sammlung der Künstlerin

6

Infundibulum

1989, glazed ceramic, 21 × 25 × 12 in.
The Contemporary Museum,
Honolulu, HI, USA

1989, glasierte Keramik, 53,3 × 63,5 × 30,5 cm
The Contemporary Museum,
Honolulu, HI, USA

7

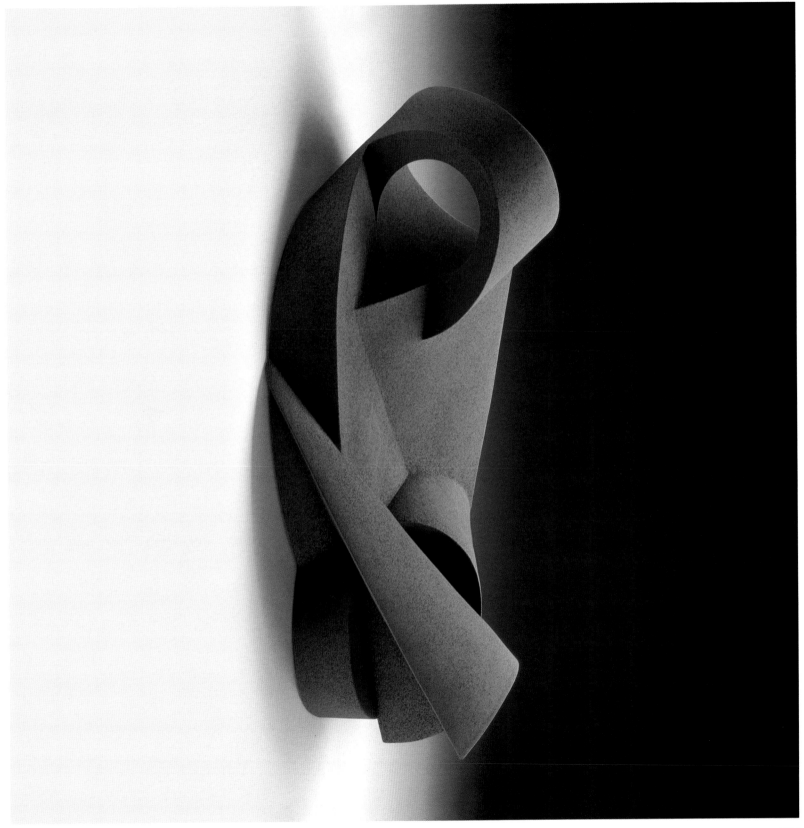

Inbound / Outbreak

1990, glazed ceramic, 23 × 29 × 20 in.
Marlin and Regina Miller, USA

1990, glasierte Keramik, 58,4 × 73,7 × 50,8 cm
Marlin und Regina Miller, USA

Horizontal Sequent: GR (wall)

1990, glazed ceramic, 22 × 34 × 9 in.
Collection of the artist

1990, glasierte Keramik, 55,9 × 86,4 × 22,9 cm
Sammlung der Künstlerin

9

Waughbrook

1990, glazed ceramic, 19 × 37 × 20 in.
Museum of Contemporary Art,
Kyoung-ju, South Korea

1990, glasierte Keramik, 48,3 × 94 × 50,8 cm
Museum für zeitgenössische Kunst,
Kyoung-ju, Süd-Korea

10

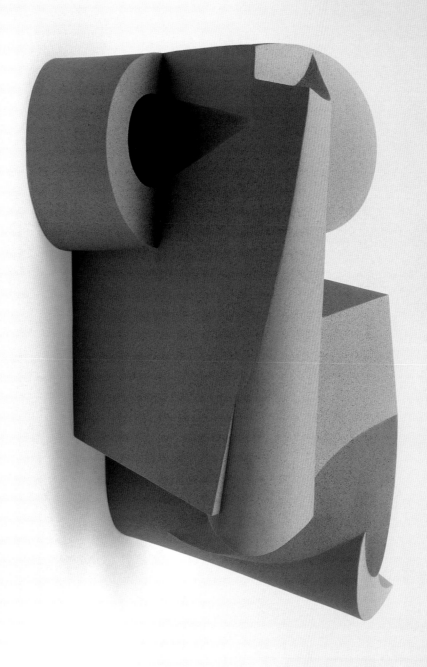

Brody Slide

Two different views
1990, glazed ceramic, 15 × 35 × 25 in.
Collection of the artist

Zwei verschiedene Ansichten
1990, glasierte Keramik, 38,1 × 88,9 × 63,5 cm
Sammlung der Künstlerin

11

Vertical Sequent BK (wall)

1990, glazed ceramic, 22 × 34 × 10 in.
Carolyn and Joe Losos, USA

1990, glasierte Keramik, 55,9 × 86,4 × 25,4 cm
Carolyn und Joe Losos, USA

12

C2TR

1992, glazed ceramic, 9 × 21 × 17 in.
Collection of the artist

1992, glasierte Keramik, 22,9 × 53,3 × 43,2 cm
Sammlung der Künstlerin

13

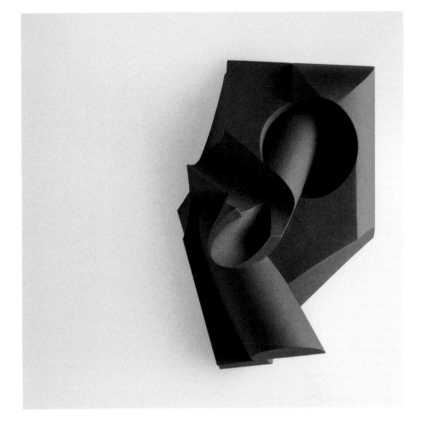

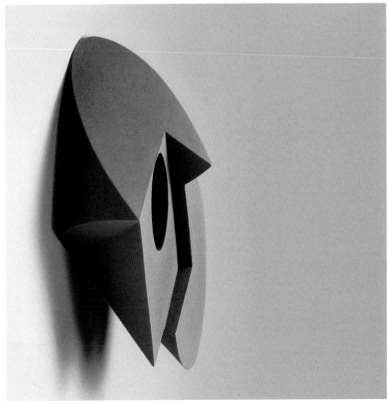

Rollway

Two different views
1992, glazed ceramic, 14 × 22 × 9 in.
Renwick Gallery, Smithsonian American Art
Museum, Washington, DC, USA

Zwei verschiedene Ansichten
1992, glasierte Keramik, 35,6 × 55,9 × 22,9 cm
Renwick Gallery, Smithsonian American Art
Museum, Washington, DC, USA

14

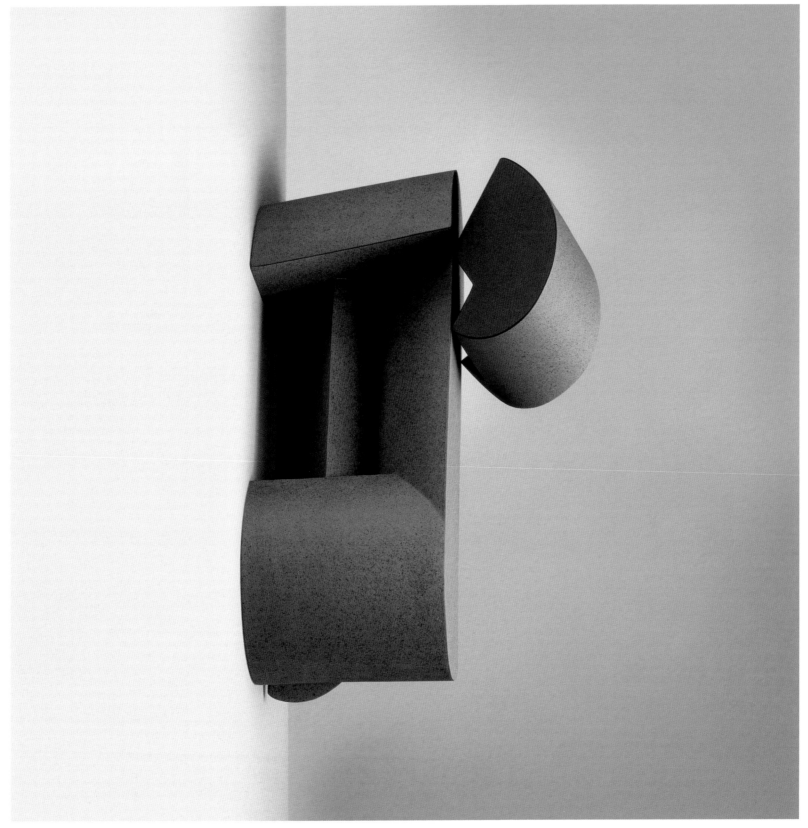

Yellow / Black Counterpoint

Two different views
1992, glazed ceramic, 14 × 27 × 12 in.
Linda and Dan Gross, USA

Zwei verschiedene Ansichten
1992, glasierte Keramik, 35,6 × 68,6 × 30,5 cm
Linda und Dan Gross, USA

15

Angulated Still Life

Two different views
1992, glazed ceramic and sanded terracotta,
10 × 23 × 14 in. (destroyed)

Zwei verschiedene Ansichten
1992, glasierte Keramik und geschmirgelte
Terrakotta, 25,4 × 58,4 × 35,6 cm (zerstört)

16

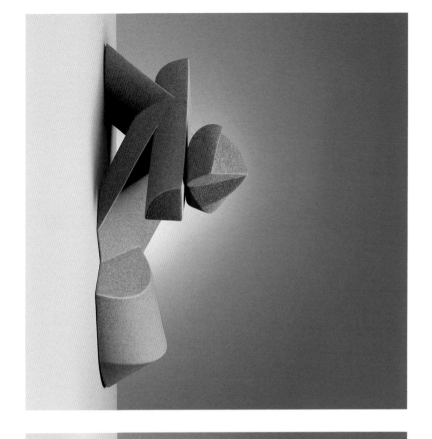

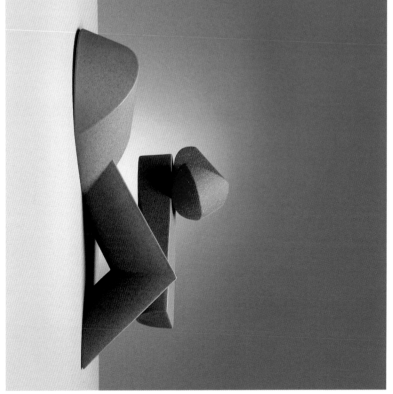

Caption for pages 42–45 / Bildlegende für Seiten 42–45

Exterior Motives

1993–95, glazed ceramic, 60 × 216 × 8 in.
Arrow International, USA

1993–95, glasierte Keramik,
152,4 × 548,6 × 20,3 cm
Arrow International, USA

17/18

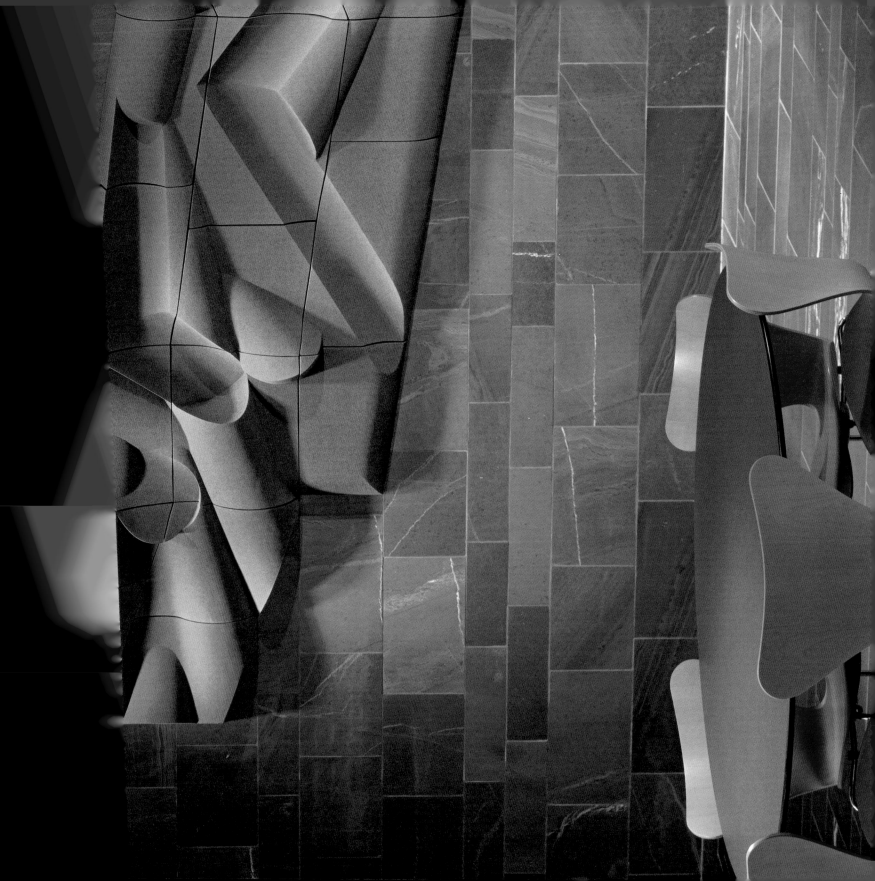

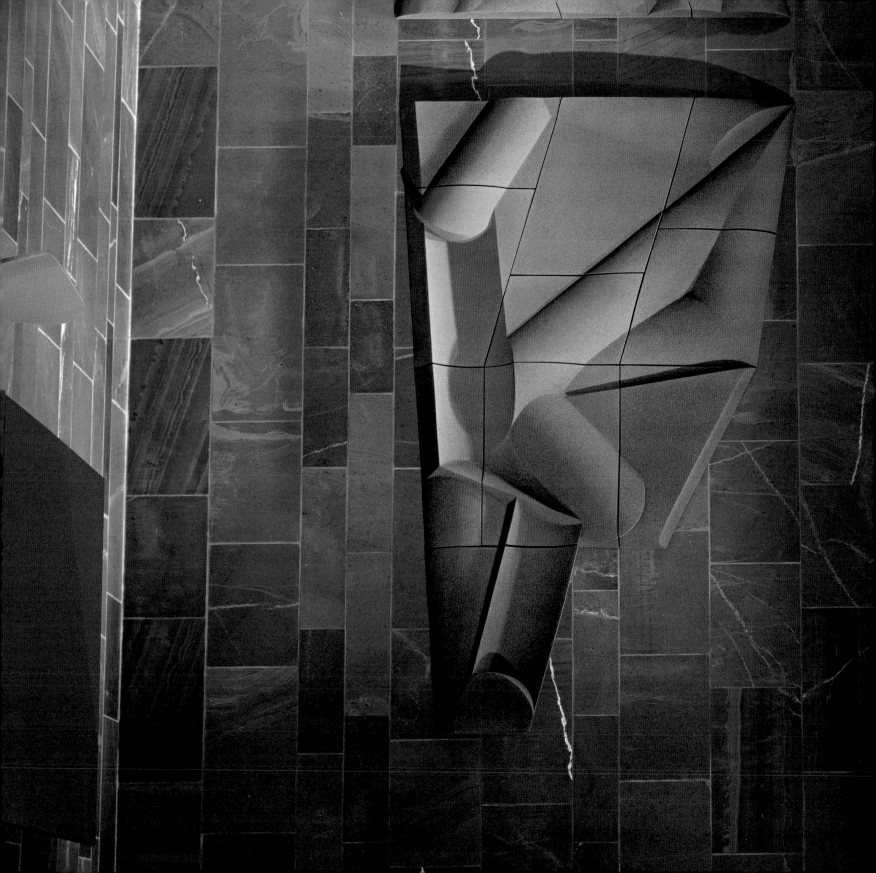

Distraction

1996, glazed ceramic, 20.5 × 24 × 10.5 in.
Metropolitan Museum of Art,
New York, NY, USA

1996, glasierte Keramik, 52,1 × 60,1 × 26,7 cm
Metropolitan Museum of Art,
New York, NY, USA

19

Fault

1996, glazed ceramic, 21 × 25 × 12 in.
Kimberly Taylor, USA

1996, glasierte Keramik, 53,3 × 63,5 × 30,5 cm
Kimberly Taylor, USA

20

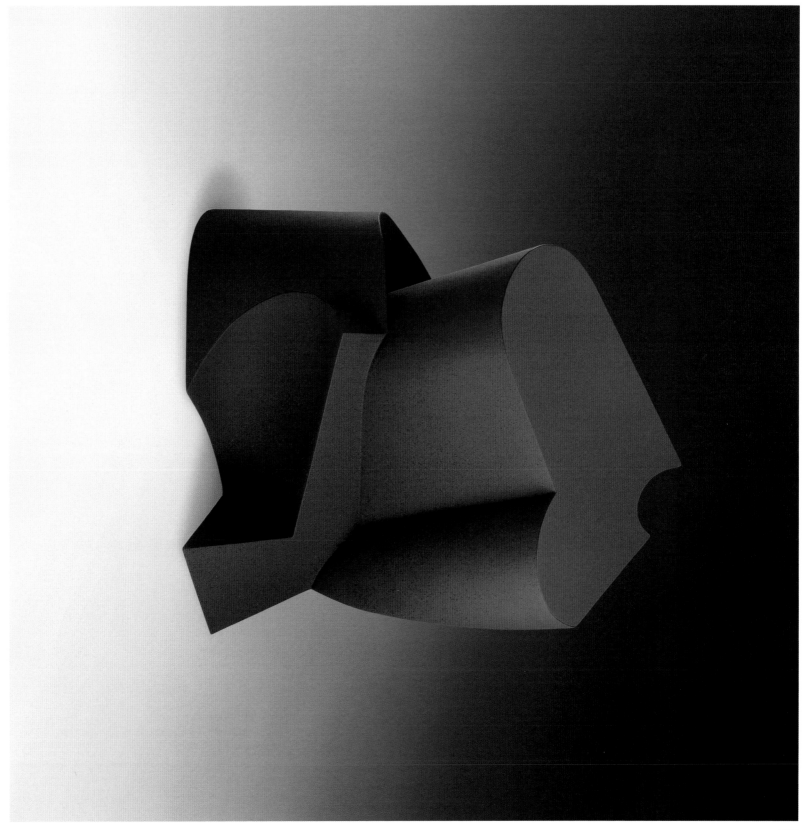

Panel Series I: Frolic

1997, glazed ceramic, 18 × 26 × 7 in.
Los Angeles County Museum of Art,
Los Angeles, CA, USA

1997, glasierte Keramik, 45,7 × 66 × 17,8 cm
Los Angeles County Museum of Art,
Los Angeles, CA, USA

21

Fold and Roll (wall)

1997, glazed ceramic, 24 × 18 × 6.5 in.
Private collection

1997, glasierte Keramik, 60,1 × 45,7 × 16,5 cm
Privatsammlung

22

Viewpoint: Triptych (wall)

1997, glazed ceramic, 24 × 52 × 6 in.
Private collection

1997, glasierte Keramik, 61 × 132,1 × 15,2 cm
Privatsammlung

23

Panel Series I: Repose

1997, glazed ceramic, 18 × 26 × 7 in.
Private collection

1997, glasierte Keramik, 45,7 × 66 × 17,8 cm
Privatsammlung

24

Panel Series I: Potential

1997, glazed ceramic, 18 × 26 × 7 in.
Hope and Mel Barkin, USA

1997, glasierte Keramik, 45,7 × 66 × 17,8 cm
Hope und Mel Barkin, USA

25

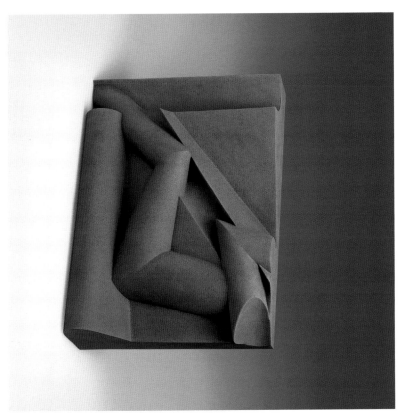

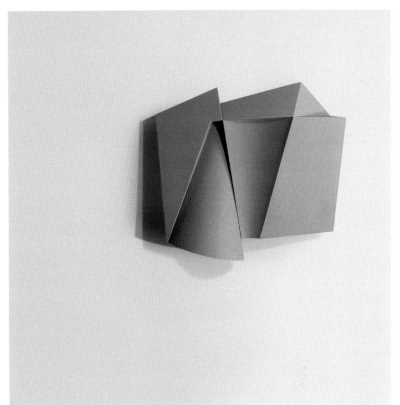

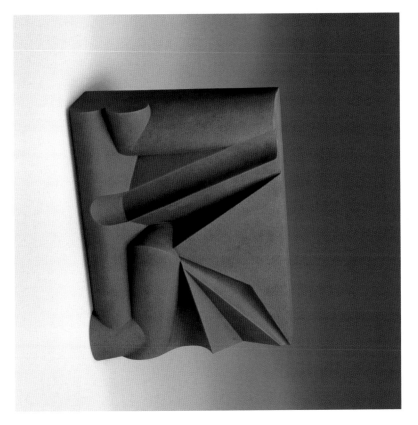

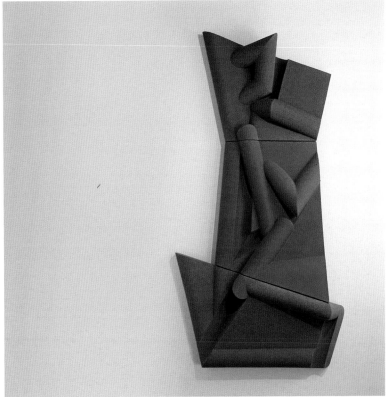

North Face

1997, glazed ceramic, 21 × 18 × 6.5 in.
Marlin and Regina Miller, USA

1997, glasierte Keramik, 53,3 × 45,7 × 16,5 cm
Marlin und Regina Miller, USA

26

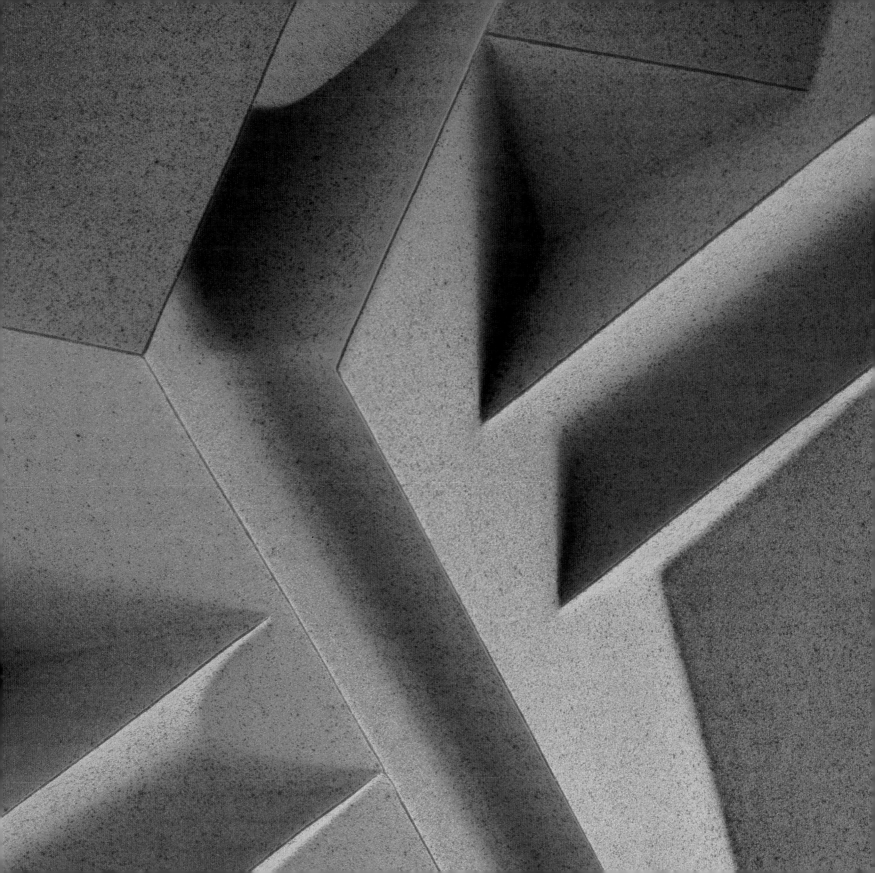

Panel (wall)

Two different views
1997, glazed ceramic, 10 × 28 × 6.5 in.
Seymour and Marcia Sabesin, USA

Zwei verschiedene Ansichten
1997, glasierte Keramik, 25,4 × 71,1 × 16,5 cm
Seymour und Marcia Sabesin, USA

27

Panel Series I: Caress

1997, glazed ceramic, 18 × 26 × 7 in.
Penelope and Peter West, USA

1997, glasierte Keramik, 45,7 × 66 × 17,8 cm
Penelope und Peter West, USA

28

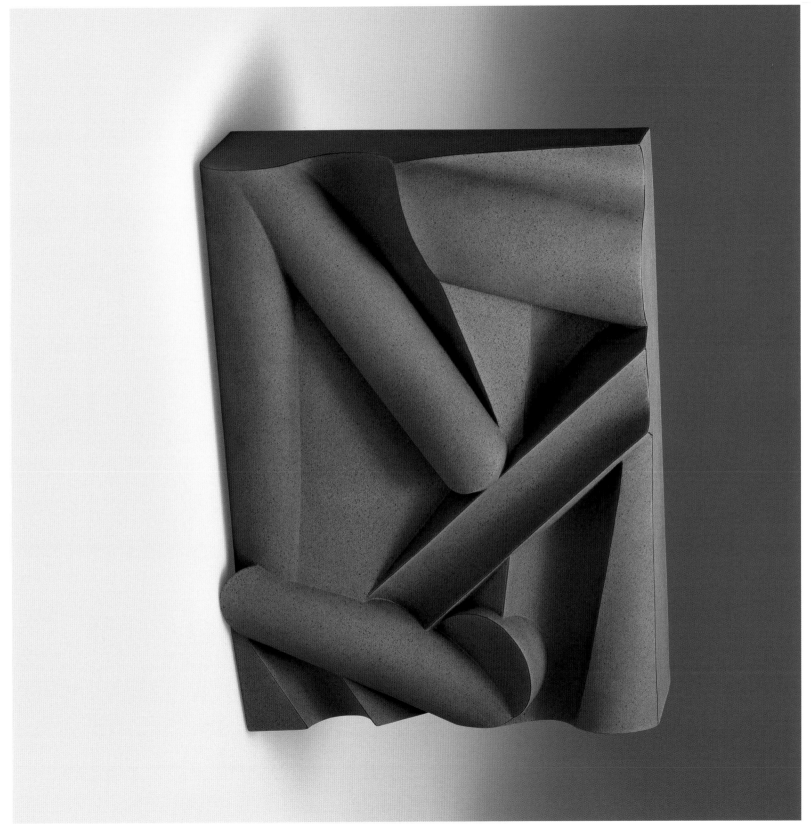

Panel Series II: Arousal

1998, glazed ceramic, 20 × 30 × 7 in.
Collection of the artist

1998, glasierte Keramik, 50,8 × 76,2 × 17,8 cm
Sammlung der Künstlerin

29

Panel Series II: Embrace

1998, glazed ceramic, 20 × 30 × 7 in.
Collection of the artist

1998, glasierte Keramik, 50,8 × 76,2 × 17,8 cm
Sammlung der Künstlerin

30

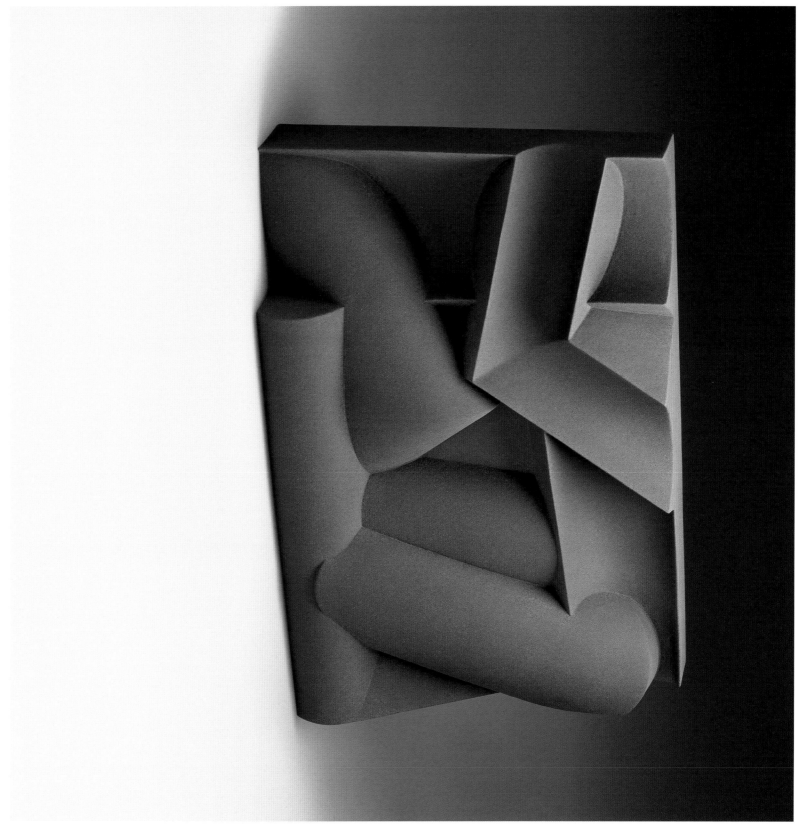

Panel Series II: In the Shallows

1998, glazed ceramic, 20 × 30 × 7 in.
Collection of the artist

1998, glasierte Keramik, 50,8 × 76,2 × 17,8 cm
Sammlung der Künstlerin

Eleusis
1999, glazed ceramic, 19 × 18 × 11 in.
Barbara Rice and Tina Phipps, USA

1999, glasierte Keramik, 48,3 × 45,7 × 28 cm
Barbara Rice und Tina Phipps, USA

32

Juncture

Four different views
1999, glazed ceramic, 22 × 17 × 17 in.
Marlin and Regina Miller, USA

Vier verschiedene Ansichten
1999, glasierte Keramik, 55,9 × 43,2 × 43,2 cm
Marlin und Regina Miller, USA

33

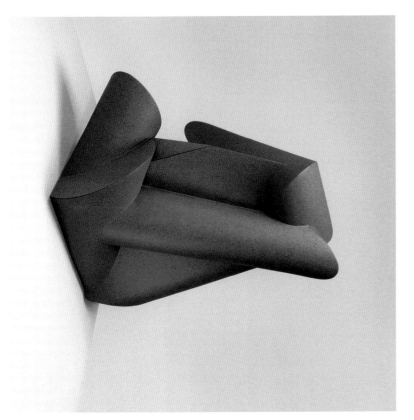

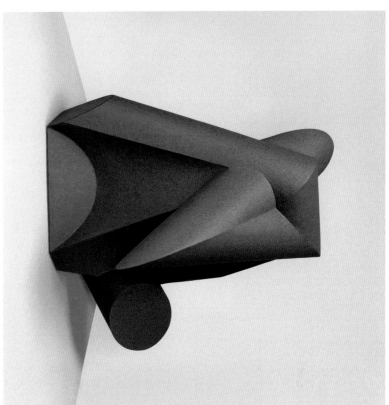

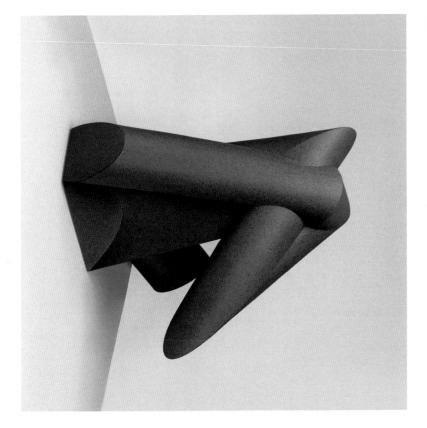

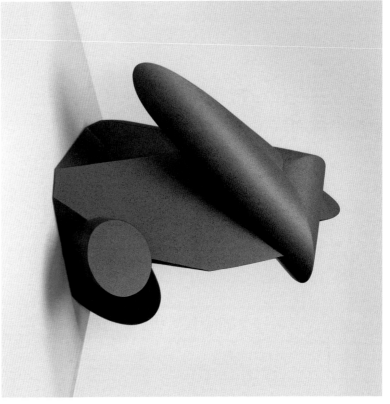

Interpolator

Two different views
1999, glazed ceramic, 22 × 24 × 16 in.
Daum Museum of Contemporary Art,
Sedalia, MO, USA

Zwei verschiedene Ansichten
1999, glasierte Keramik, 55,9 × 60,1 × 40,6 cm
Daum Museum of Contemporary Art,
Sedalia, MO, USA

34

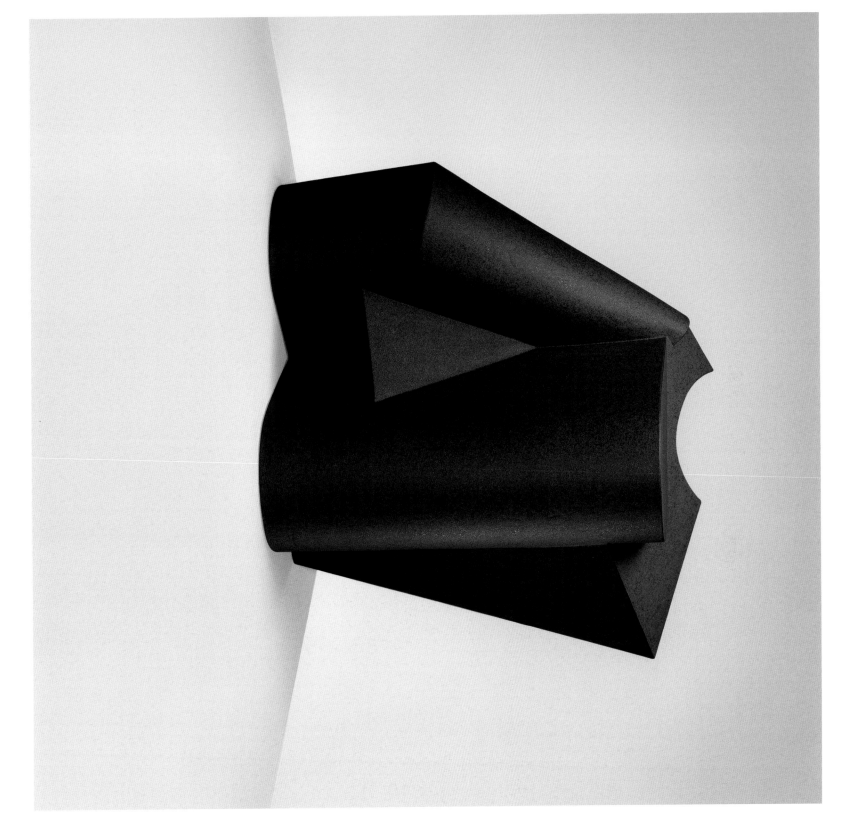

Backslide

1999, glazed ceramic, 20 × 24 × 11 in.
Dr. Oliver Habel, Germany

1999, glasierte Keramik, 50,8 × 60,1 × 27,9 cm
Dr. Oliver Habel, Deutschland

35

Dipolar Association

1999, glazed ceramic, 18.5 × 20 × 20 in.
Collection of the artist

1999, glasierte Keramik, 47 × 50,8 × 50,8 cm
Sammlung der Künstlerin

36

Set-Up

1999, glazed ceramic, 17 × 23 × 16 in.
Collection of the artist

1999, glasierte Keramik, 43,2 × 58,4 × 40,6 cm
Sammlung der Künstlerin

37

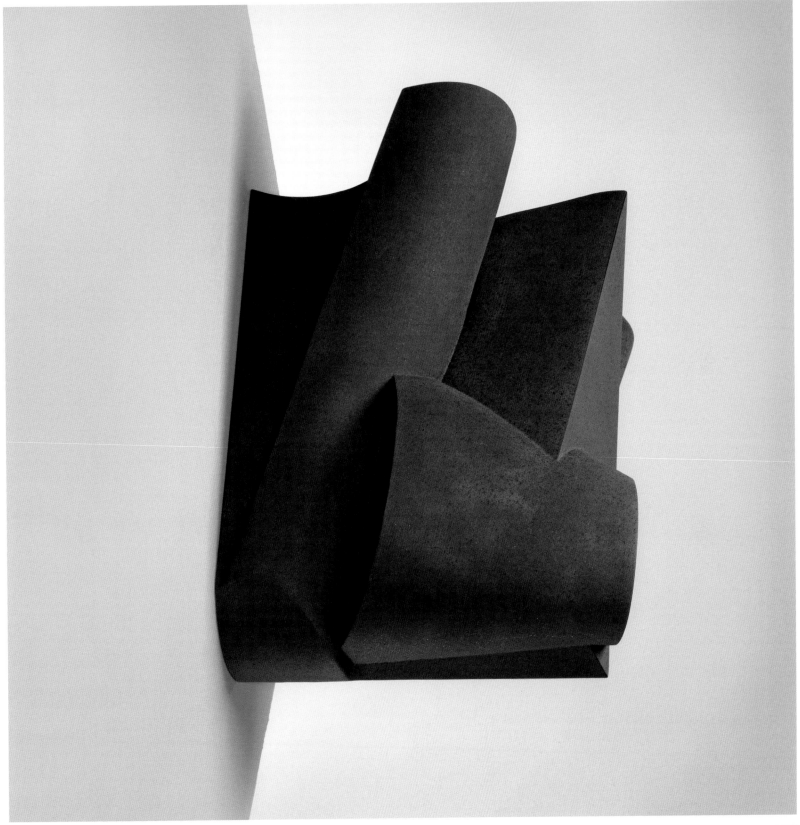

Conduit

Two different views
2000, glazed ceramic, 17.75 × 20 × 18 in.
Irene and Barry Fisher, USA

Zwei verschiedene Ansichten
2000, glasierte Keramik, 45,1 × 50,8 × 45,7 cm
Irene und Barry Fisher, USA

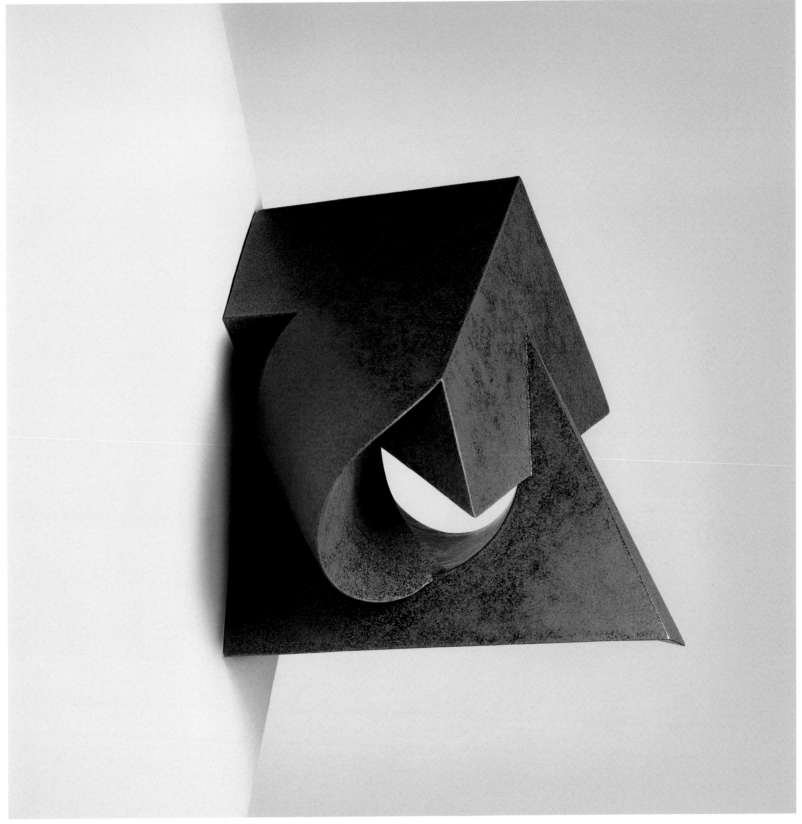

First of June

Two different views
2002, glazed ceramic, 27 × 20 × 21 in.
Memorial Art Gallery, Rochester, NY, USA

Zwei verschiedene Ansichten
2002, glasierte Keramik, 68,6 × 50,8 × 53,3 cm
Memorial Art Gallery, Rochester, NY, USA

39

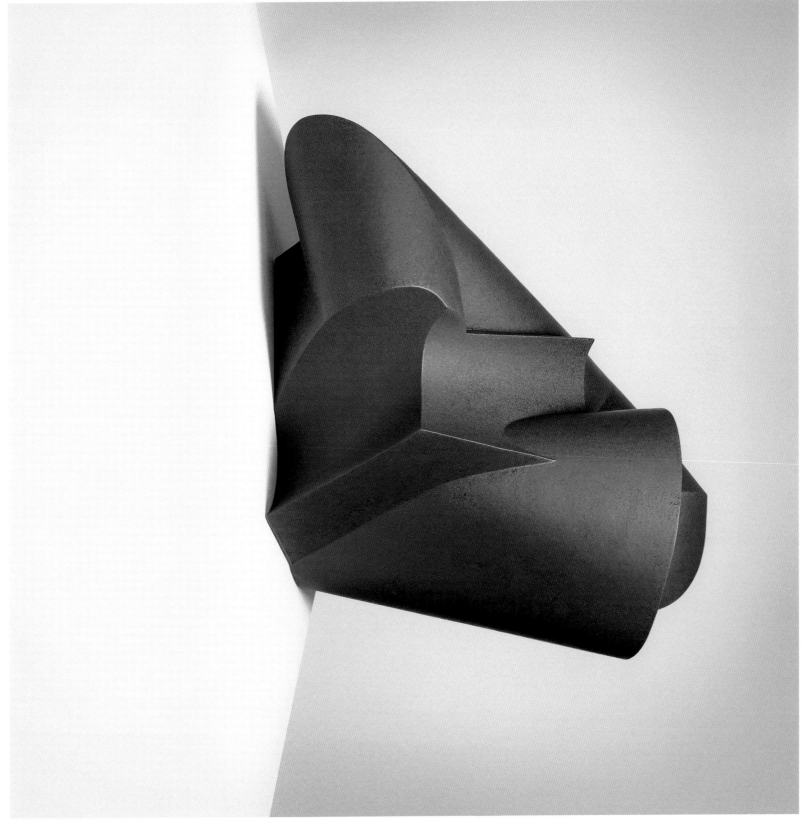

Envelop

2001, glazed ceramic, 17.5 × 28 × 23 in.
Mark Landrum, First National Bank,
Columbia, MO, USA

2001, glasierte Keramik, 44,5 × 71,1 × 58,4 cm
Mark Landrum, First National Bank,
Columbia, MO, USA

Torque

2001, glazed ceramic, 21 × 25 × 21 in.
Jeffrey Shankman, USA

2001, glasierte Keramik, 53,3 × 63,5 × 53,3 cm
Jeffrey Shankman, USA

41

Bridge

2001, glazed ceramic, 20 × 26 × 20 in.
World Ceramic Exposition Foundation,
Icheon World Ceramic Center, Icheon City,
Gyeonggi-do, South Korea

2001, glasierte Keramik, 50,8 × 66 × 50,8 cm
World Ceramic Exposition Foundation,
Icheon World Ceramic Center, Icheon City,
Gyeonggi-do, Süd-Korea

42

Capri
2001, glazed ceramic, 16 × 27 × 21 in.
J. B. Speed Art Museum, Louisville, KY, USA
2001, glasierte Keramik, 40,6 × 68,6 × 53,3 cm
J. B. Speed Art Museum, Louisville, KY, USA
43

Span
2001, glazed ceramic, 25 × 25 × 22 in.
Seymour and Marcia Sabesin, USA
2001, glasierte Keramik, 63,5 × 63,5 × 55,9 cm
Seymour und Marcia Sabesin, USA
44

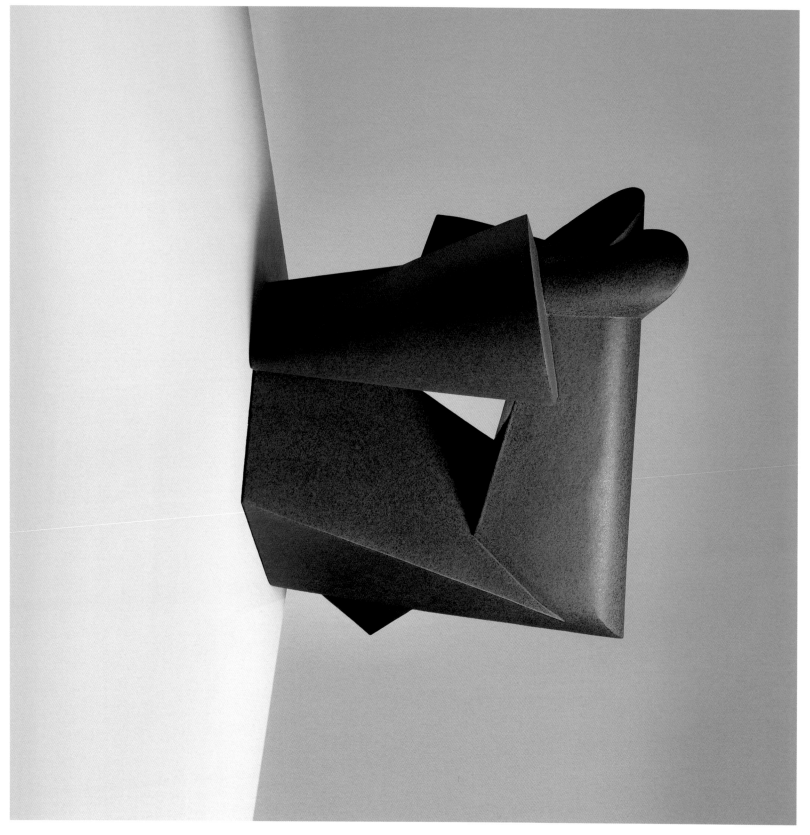

Homage

Two different views
2001, glazed ceramic, 25 × 24 × 21 in.
Collection of the artist

Zwei verschiedene Ansichten
2001, glasierte Keramik, 63,5 × 61 × 53,3 cm
Sammlung der Künstlerin

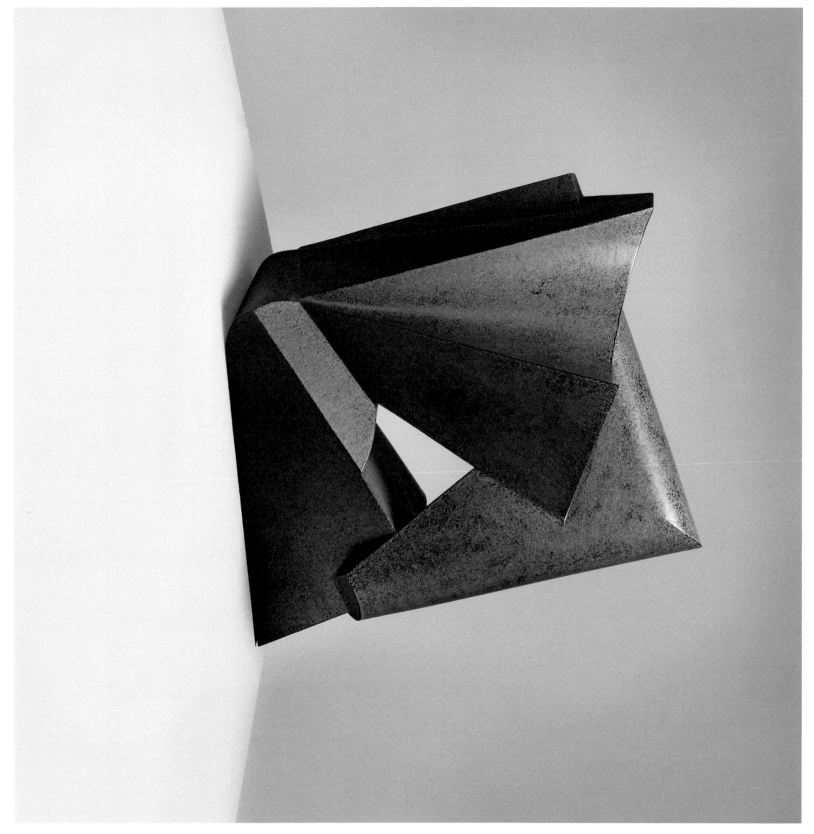

Ricochet

2001, glazed ceramic, 18 × 23 × 28 in.
Dr. Charles Nichols, USA

2001, glasierte Keramik, 45,7 × 58,4 × 71,1 cm
Dr. Charles Nichols, USA

46

Pivotal Moment

Two different views
2002, glazed ceramic, 12 × 29 × 10 in.
Collection of the artist

Zwei verschiedene Ansichten
2002, glasierte Keramik, 30,5 × 73,7 × 25,4 cm
Sammlung der Künstlerin

47

Contraction

Two different views
2002, glazed ceramic, 27 × 24 × 27.5 in.
Collection of the artist

Zwei verschiedene Ansichten
2002, glasierte Keramik, 68,6 × 60,1 × 69,9 cm
Sammlung der Künstlerin

48

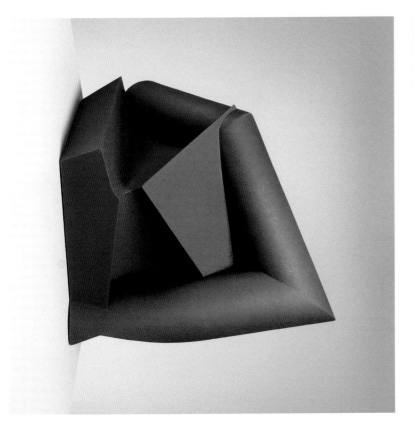

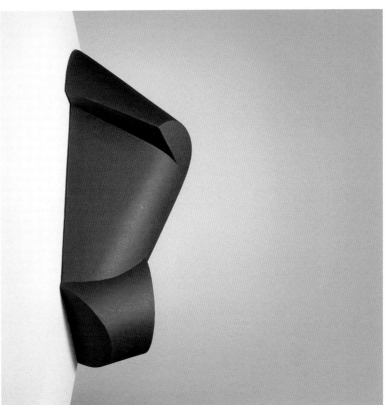

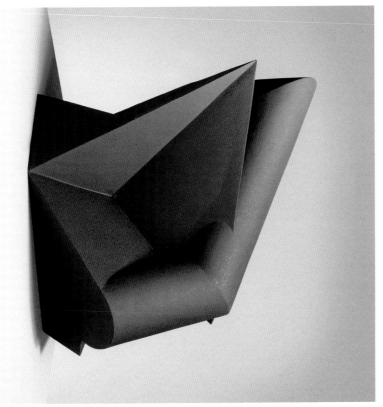

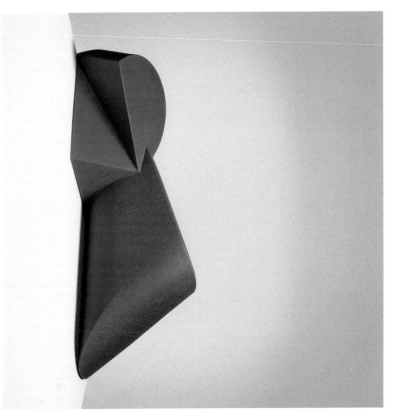

Eight Rockers
2002, soda-fired ceramics, assorted sizes
Various collections

2002, mit Soda gebrannte Keramiken,
verschiedene Größen
Verschiedene Sammlungen

49

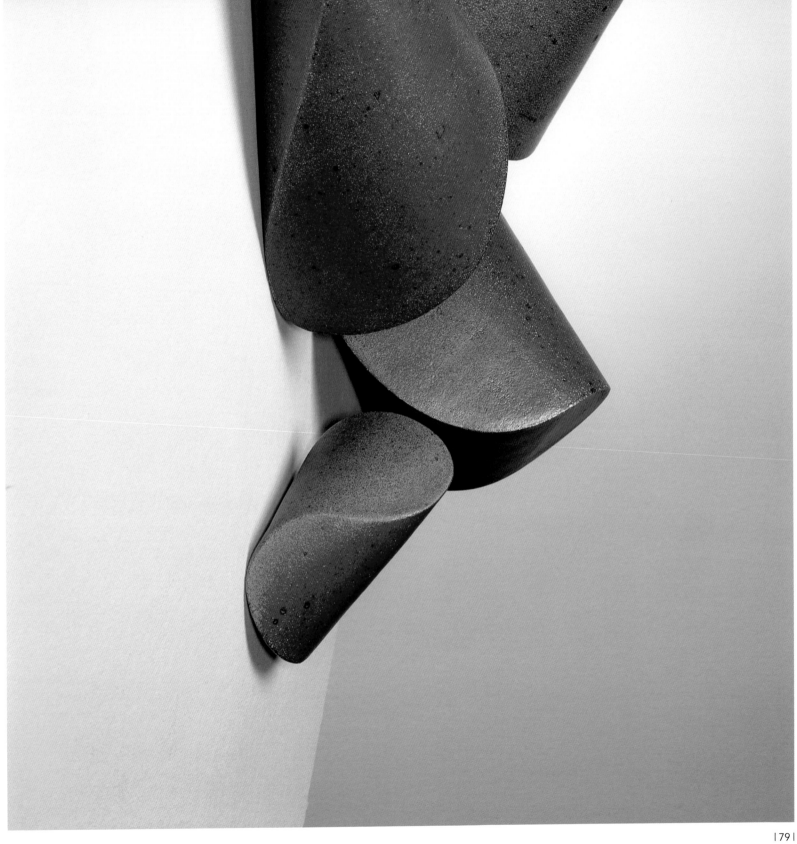

Adjunct
2004, glazed ceramic, 22.5 × 22 × 22 in.
Collection of the artist
2004, glasierte Keramik, 57,2 × 55,9 × 55,9 cm
Sammlung der Künstlerin
50

Wadsworth
2004, glazed ceramic, 28 × 28 × 25 in.
The Cardin Family, USA
2004, glasierte Keramik, 71 × 71 × 68 cm
Familie Cardin, USA
51

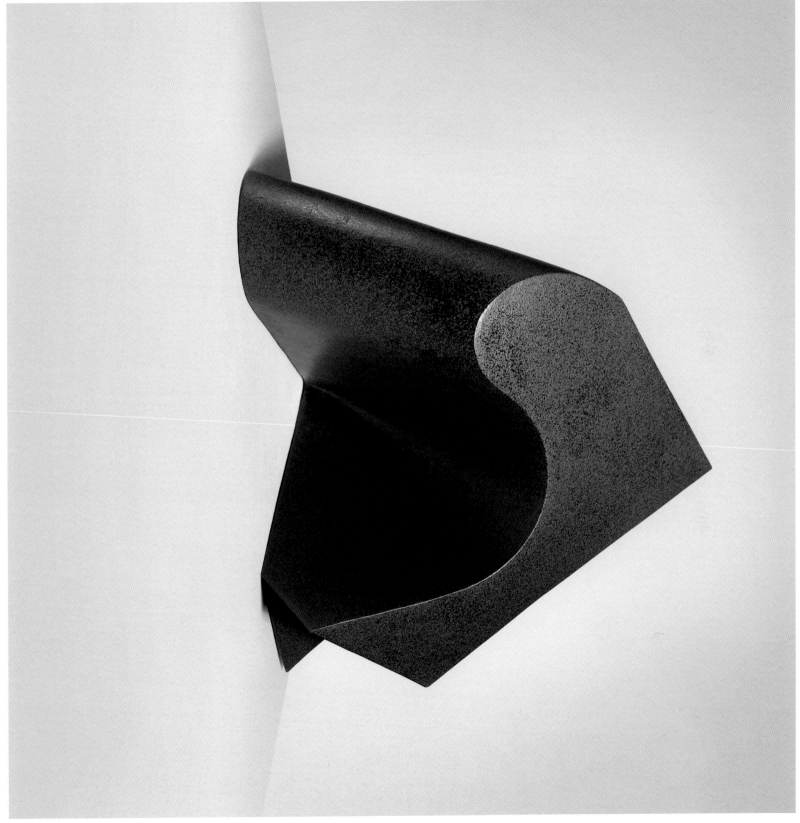

Duke

Two different views
2004, glazed ceramic, 23 × 28 × 20 in.
Susan and Robert Spencer, USA

Zwei verschiedene Ansichten
2004, glasierte Keramik, 58,4 × 71,1 × 50,8 cm
Susan und Robert Spencer, USA

52

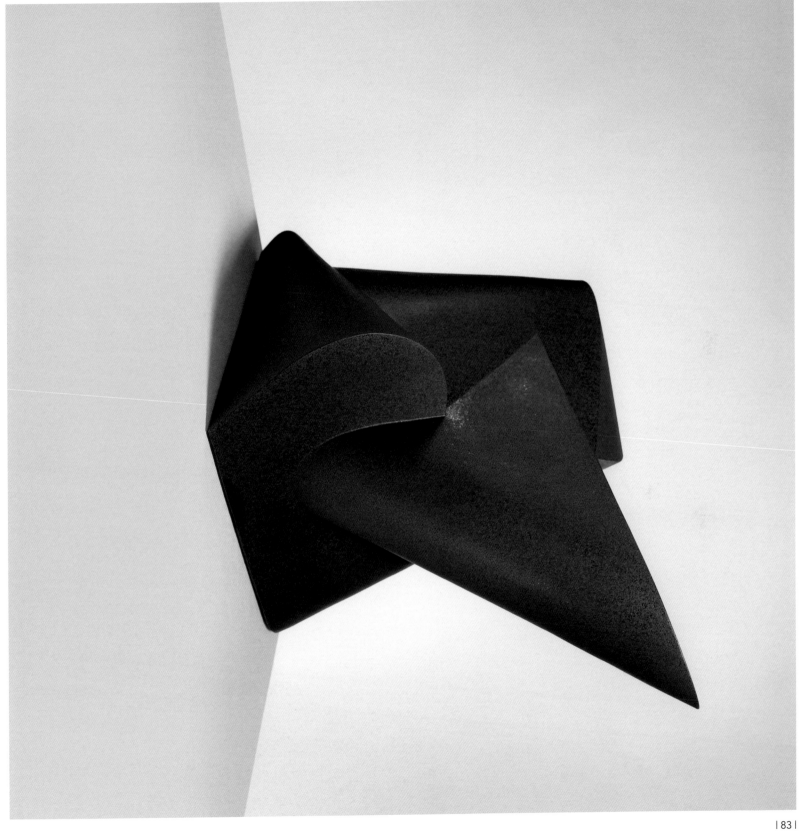

Belleclaire (wall)

2005, glazed ceramic, 21 × 21 × 8 in.
Collection of the artist

2005, glasierte Keramik, 53,3 × 53,3 × 20,3 cm
Sammlung der Künstlerin

53

Fancy Tract (wall)

2005, glazed ceramic, 18.5 × 22 × 9 in.
Collection of the artist

2005, glasierte Keramik, 47 × 55,9 × 22,9 cm
Sammlung der Künstlerin

54

Vandermark (wall)

2005, glazed ceramic, 20.5 × 21.5 × 5 in.
Collection of the artist

2005, glasierte Keramik, 52,1 × 54,6 × 12,7 cm
Sammlung der Künstlerin

55

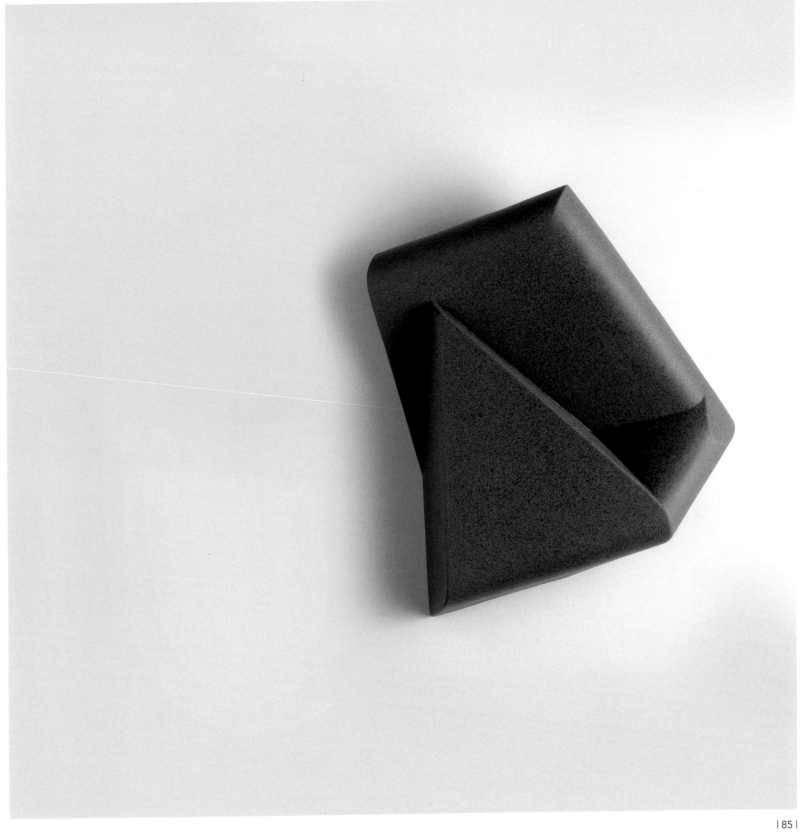

Madison

Two different views
2005, glazed ceramic, 18.5 × 19 × 15 in.
Collection of the artist

Zwei verschiedene Ansichten
2005, glasierte Keramik, 47 × 48,3 × 38,1 cm
Sammlung der Künstlerin

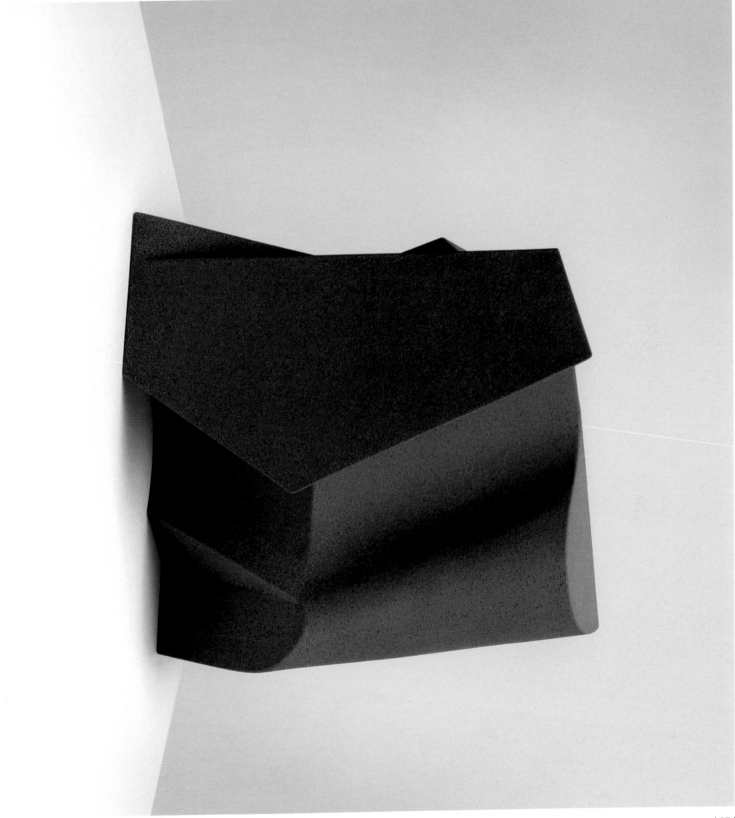

Belmont

2004, glazed ceramic, 26 × 17 × 21 in.
Collection of the artist

2004, glasierte Keramik, 66 × 43,2 × 53,3 cm
Sammlung der Künstlerin

57

Vorticella

2005, glazed ceramic, 14 × 23 × 18 in.
Kunstsammlungen der Veste Coburg, Germany
Gift of Otto Waldrich, Germany

2005, glasierte Keramik, 35,6 × 58,4 × 45,7 cm
Kunstsammlungen der Veste Coburg, Deutschland
Geschenk von Otto Waldrich, Deutschland

58

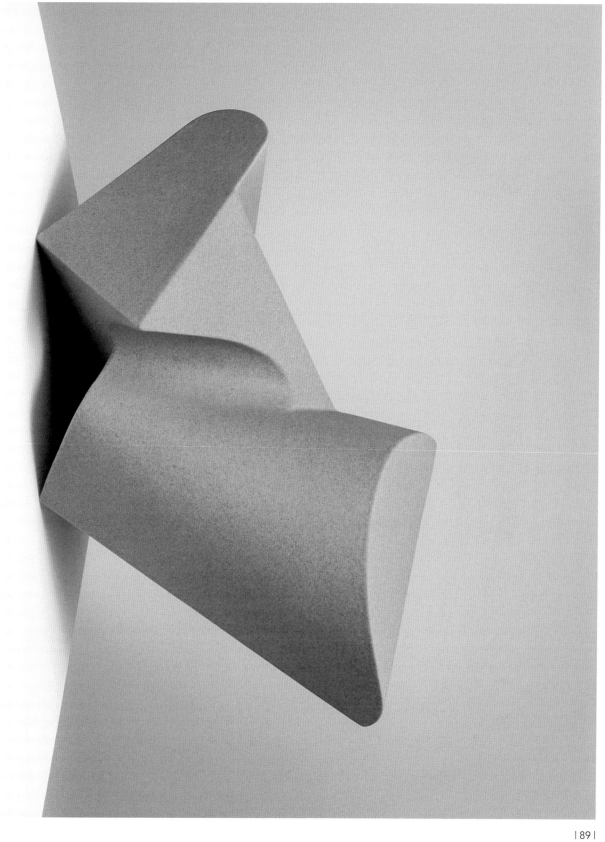

Kinzua

2005, glazed ceramic, 15.5 × 21 × 20.5 in.
Collection of the artist

2005, glasierte Keramik, 39,4 × 53,3 × 52,1 cm
Sammlung der Künstlerin

59

Angelica

Two different views
2005, glazed ceramic, 16 × 18 × 15 in.
Collection of the artist

Zwei verschiedene Ansichten
2005, glasierte Keramik, 40,6 × 45,7 × 38 cm
Sammlung der Künstlerin

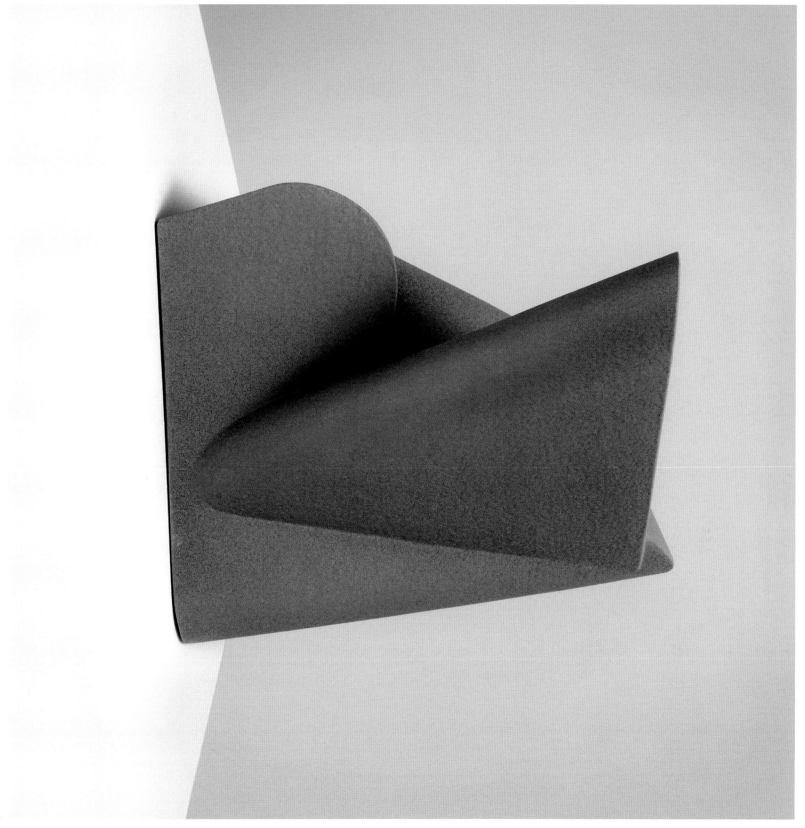

Allegheny

2005, glazed ceramic, 18.5 × 23 × 20 in.
Collection of the artist

2005, glasierte Keramik, 47 × 58,4 × 50,8 cm
Sammlung der Künstlerin

61

Shongo

2005, glazed ceramic, 12 × 21 × 15 in.
Collection of the artist

2005, glasierte Keramik, 30,5 × 53,3 × 38,1 cm
Sammlung der Künstlerin

62

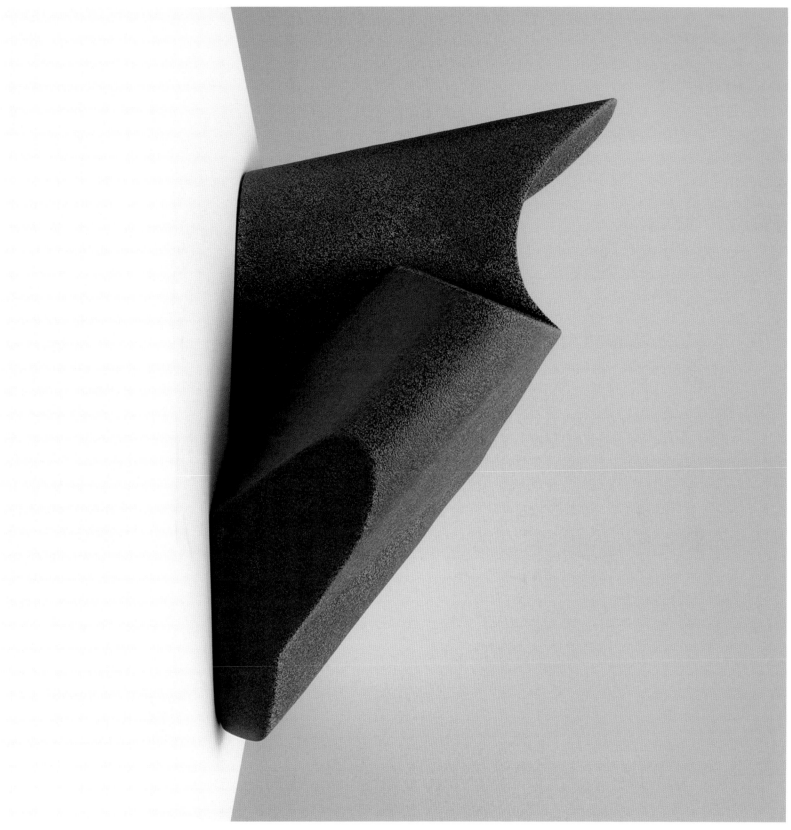

Roulette
Two different views
2005, glazed ceramic, 9 × 12.5 × 10.5 in.
Collection of the artist

Zwei verschiedene Ansichten
2005, glasierte Keramik, 22,9 × 31,8 × 26,7 cm
Sammlung der Künstlerin

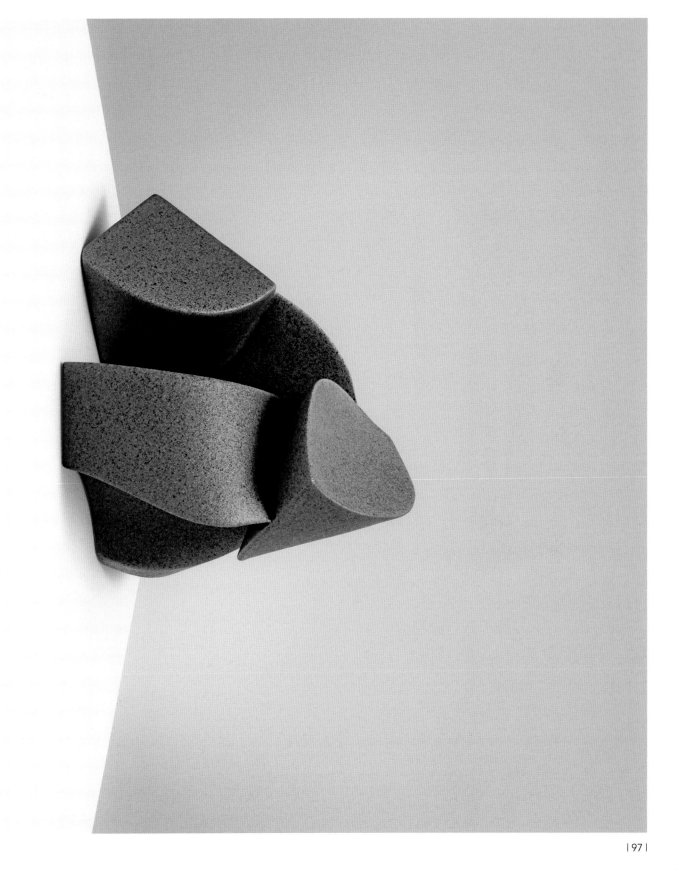

Withey

Two different views
2005, glazed ceramic, 19 × 22 × 18.5 in.
Collection of the artist

Zwei verschiedene Ansichten
2005, glasierte Keramik, 48,3 × 55,9 × 47 cm
Sammlung der Künstlerin

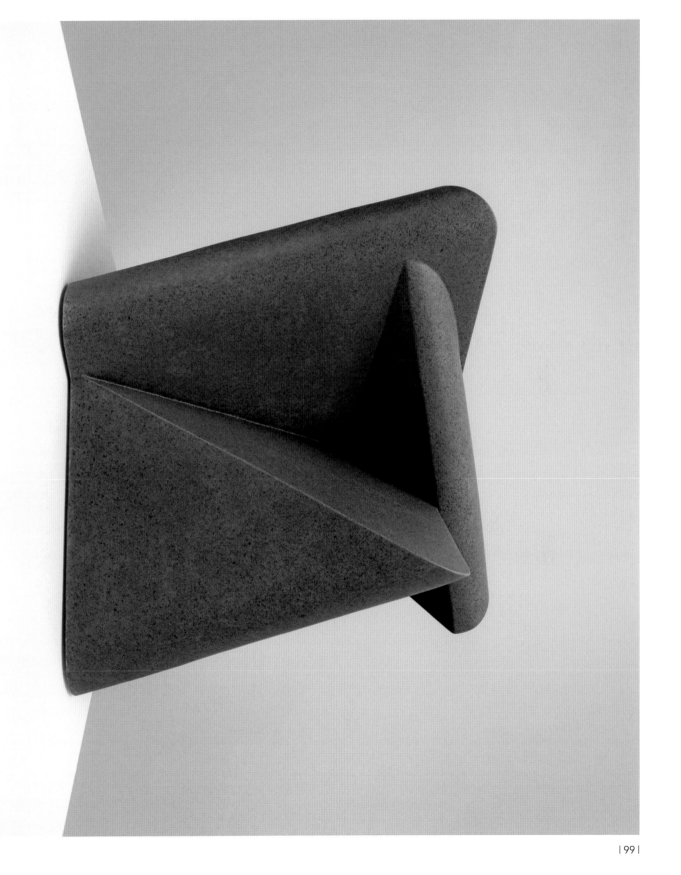

Midas

2006, glazed ceramic, 5.5 × 14 × 11 in.
Karoline and Robert Dunne, USA

2006, glasierte Keramik, 14 × 35,5 × 28 cm
Karoline und Robert Dunne, USA

65

Stannards

2005, glazed ceramic, 16.5 × 29 × 6.5 in.
Collection of the artist

2005, glasierte Keramik, 41,9 × 73,7 × 16,5 cm
Sammlung der Künstlerin

66

Wisp

2005, glazed ceramic, 6.5 × 12 × 8 in.
Collection of the artist

2005, glasierte Keramik, 16,5 × 30,5 × 20,3 cm
Sammlung der Künstlerin

67

Pivot

2006, glazed ceramic, 7 × 20 × 7 in.
Marshall Sklar, USA

2006, glasierte Keramik, 17,8 × 50,8 × 17,8 cm
Marshall Sklar, USA

68

Wayland

2005, glazed ceramic, 13.5 × 16 × 17.5 in.
Collection of the artist

2005, glasierte Keramik, 34,3 × 40,6 × 44,4 cm
Sammlung der Künstlerin

69

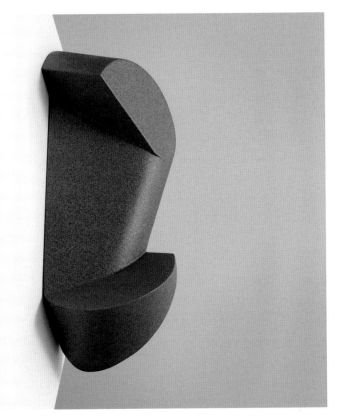
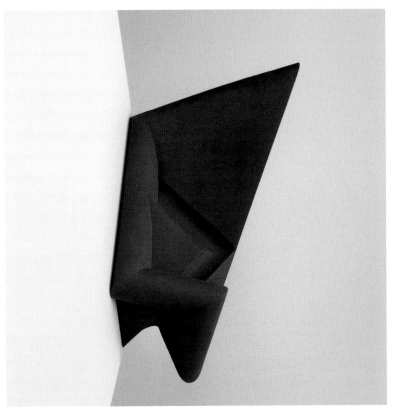
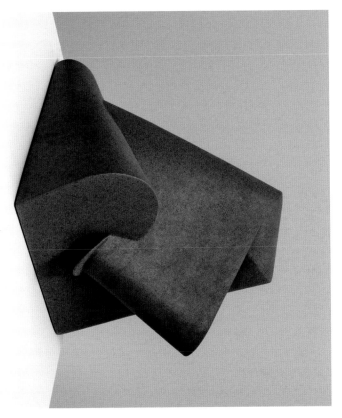
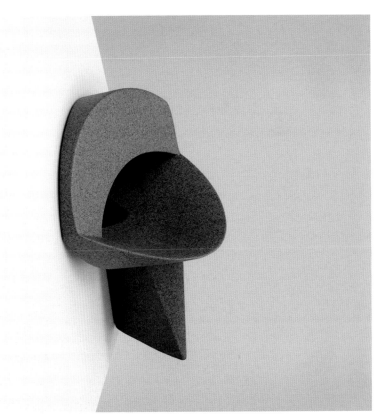

Cadiz

Two different views
2005, glazed ceramic, 15 × 26.5 × 18 in.
Helen W. Drutt English, USA

Zwei verschiedene Ansichten
2005, glasierte Keramik, 38 × 67,3 × 45,7 cm
Helen W. Drutt English, USA

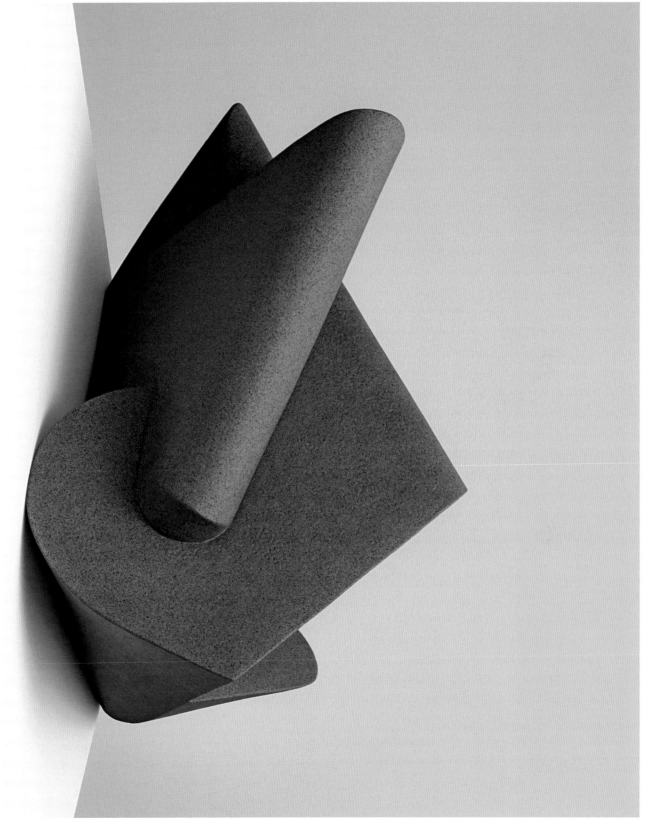

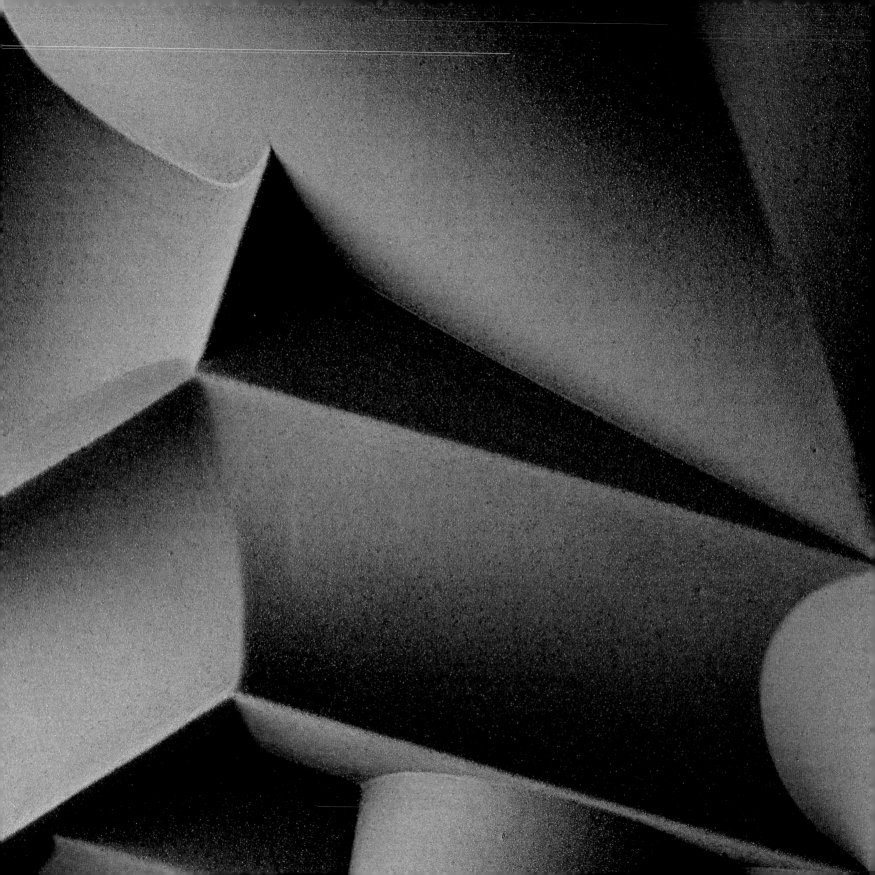

Artist Statement

I make ceramic sculptures that are shaped by the interplay of masses and voids. Projection and recession, light and shadow, substance and impression are the subject matter of my work. The shapes are the players, intersecting, extending, colliding or passing through / over / under / beyond one another to command space. Through the simplicity of clay cylinders, cones, planes and edges, I can indulge my compulsion to experience both inside and outside spaces. On some occasions, references to the human body are present. Positions of human figures found in Greek and Buddhist temple pediments and friezes intrigue me: the dynamics of their composition, narrative and scale are charged as a result of their placement within defined architectural spaces. The rich subtleties and contrasts of winter colors that I see here in Allegany County are sources for glaze colors: charcoal blacks, slate blue/grays, deep rusts and warm tans. Color and texture are intended to create an ambiguity about surface and touch. Although the fired glaze surface appears soft, it is hard and feels like sandpaper. This visual/tactile aspect of the surface, combined with light and shadow, triggers visual illusions and spatial ambiguities. My research as an artist and teacher is not singular nor can it be easily defined in linear terms or simple formats. It is a slimy, laminated, organic and most often semi-opaque pursuit as my interests are diverse and seemingly unconnected. Paying attention and playing with the possibilities that the dots, lines and layers are connectable and interchangeable in time and space might describe my engagement and activities as artist and teacher. From another vantage point, I see myself as an instigator and maker, a catalyst for creating collision courses and triggering chains of events – sometimes with ceramic material and processes, sometimes with occasions and facilities that bring people and opportunities together. Observation is always essential.

Education

1974 M.F.A. University of Washington, Seattle, WA
1972 B.F.A. School of the Art Institute of Chicago, IL

Awards

2005 The Joseph Kruson Trust Fund Award for Excellence in Teaching, Alfred University 2003 The Joseph Kruson Trust Fund Award for Excellence in Teaching, Alfred University 1997 New York Foundation for the Arts, Individual Artist Fellowship 1993 New York Foundation for the Arts, Individual Artist Fellowship 1991 Virginia A. Groot Foundation, Evanston, IL, Recognition Grant 1988 New York Foundation for the Arts, Individual Artist Fellowship 1986 National Endowment for the Arts, Visual Artists Fellowship

Academic Appointments

From 1994 Professor of Ceramic Art, New York State College of Ceramics at Alfred University, Alfred, NY 1994–1999 Chair, Division of Ceramic Art, New York State College of Ceramics at Alfred University, Alfred, NY 1985–1994 Associate Professor, New York State College of Ceramics at Alfred University, Alfred, NY 1975–1985 Department of Fine Arts, University of Colorado, Boulder, CO

Solo Exhibitions (selected)

2006 Galerie b15, Munich, Germany / Hurong Lou Gallery, Philadelphia, PA / art Karlsruhe, International Fair for Modern Art, Karlsruhe, Germany 2000 Helen Drutt Gallery, Philadelphia, PA 1998 Long Island University, Southampton, NY 1997 Helen Drutt Gallery, Philadelphia, PA 1995 Helen Drutt Gallery, Philadelphia, PA 1992 Pro Art Gallery, St. Louis, MO / Kavesh Gallery, Ketchum, ID 1990 Helen Drutt Gallery, New York, NY 1988 Helen Drutt Gallery, Philadelphia, PA 1985 Helen Drutt Gallery, Philadelphia, PA 1984 Carson Sapiro Gallery, Denver, CO 1981 Carson Sapiro Gallery, Denver, CO 1980 Exhibit A Gallery, Chicago, IL

Die Künstlerin zu ihrem Werk

Ich gestalte Skulpturen, die durch das Zusammenspiel von Masse und Hohlraum geformt sind. Vorstehendes und Zurückweichendes, Licht und Schatten, Substanz und Impression sind Gegenstand meiner Arbeiten. Die Formen sind die Akteure: Sie kreuzen sich, dehnen sich aus, kollidieren oder laufen durch-, über-, unter- und nebeneinander und beherrschen so den Raum. Durch die Einfachheit von Zylindern, Kegeln, Ebenen und Kanten aus Ton kann ich meiner Neugier für innere und äußere Räume nachgehen. Gelegentlich finden sich in meiner Arbeit Verweise auf den menschlichen Körper. Die Haltung menschlicher Figuren, wie man sie in griechischen und buddhistischen Tempelgiebeln und -friesen findet, fasziniert mich: Die Dynamik ihrer Komposition, ihrer Geschichte und ihrer Maße ist das Ergebnis ihrer Platzierung in begrenzten architektonischen Räumen. Die Winterfarben, die ich hier in Allegany County (Upstate New York, USA) sehe und die reich an Nuancen und Gegensätzen sind, bilden die Quelle für die Glasurfarben: holzkohlefarbene Schwarztöne, Schieferblau und -grau, intensive Rostfarben und warme Brauntöne. Farbe und Struktur sollen der Oberfläche eine mehrdeutige Erscheinung verleihen. Obwohl die gebrannte und glasierte Oberfläche weich erscheint, ist sie hart und fühlt sich wie Sandpapier an. Dieser visuelle und fühlbare Aspekt der Oberfläche in Kombination mit Licht und Schatten erzeugt optische Illusionen und räumliche Mehrdeutigkeit. Meine Forschungen als Künstlerin und Lehrerin sind weder einzigartig noch lassen sie sich schlicht in linearen Begriffen oder einfachen Formaten definieren. Es handelt sich vielmehr um einen nicht leicht zu fassenden, vielschichtigen, organischen und meist nicht ganz durchsichtigen Prozess, da meine Interessen verschiedenartig und scheinbar ohne Zusammenhang sind. Aufmerksamkeit sowie das Spiel mit der Möglichkeit, dass die Punkte, Linien und Schichten in Zeit und Raum verknüpfbar und austauschbar sind, könnten meine Einstellung und meine Aktivitäten als Künstlerin und Lehrerin beschreiben. Aus einem anderen Blickwinkel sehe ich mich selbst als Initiatorin und Macherin, als einen Auslöser von Kollisionskursen und Ereignisketten – manchmal hinsichtlich keramischen Materials und Prozessen, ein andermal im Hinblick auf Ereignisse und Gelegenheiten, die Menschen und Möglichkeiten zusammenbringen. Beobachtung ist dabei immer die Hauptsache.

Ausbildung

1974 M.F.A. University of Washington, Seattle, WA
1972 B.F.A. School of the Art Institute of Chicago, IL

Auszeichnungen

2005 The Joseph Kruson Trust Fund Award for Excellence in Teaching, Alfred University 2003 The Joseph Kruson Trust Fund Award for Excellence in Teaching, Alfred University 1997 New York Foundation for the Arts, Individual Artist Fellowship 1993 New York Foundation for the Arts, Individual Artist Fellowship 1991 Virginia A. Groot Foundation, Evanston, IL, Recognition Grant 1988 New York Foundation for the Arts, Individual Artist Fellowship 1986 National Endowment for the Arts, Visual Artists Fellowship

Akademische Berufungen

Seit 1994 Professor of Ceramic Art, New York State College of Ceramics at Alfred University, Alfred, NY 1994–1999 Chair, Division of Ceramic Art, New York State College of Ceramics at Alfred University, Alfred, NY 1985–1994 Associate Professor, New York State College of Ceramics at Alfred University, Alfred, NY 1975–1985 Department of Fine Arts, University of Colorado, Boulder, CO

Einzelausstellungen (Auswahl)

2006 Galerie b15, München, Deutschland / Hurong Lou Gallery, Philadelphia, PA / art Karlsruhe, Internationale Messe für Klassische Moderne und Gegenwartskunst, Karlsruhe, Deutschland 2000 Helen Drutt Gallery, Philadelphia, PA 1998 Long Island University, Southampton, NY 1997 Helen Drutt Gallery, Philadelphia, PA 1995 Helen Drutt Gallery, Philadelphia, PA 1992 Pro Art

Anne Currier

Cup and Saucer

1972, glazed earthenware, 7 × 5 in.
Private collection

1972, glasiertes Steingut, 17,7 × 12,7 cm
Privatsammlung

Tubular Double Cup Box

1973, glazed earthenware, 5 × 12 × 12 in.
Collection of the artist

1973, glasiertes Steingut, 12,7 × 30,5 × 30,5 cm
Sammlung der Künstlerin

A Cozy Cup

1972, glazed earthenware, 6 × 10 × 9 in.
Private collection

1972, glasiertes Steingut, 15,2 × 25,4 × 22,8 cm
Privatsammlung

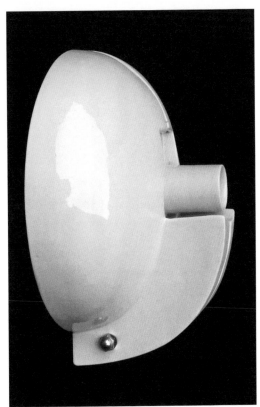

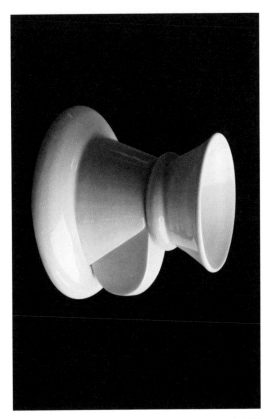

B/W Cup Box Series: Black

Two different views
1977, glazed ceramic, 4 × 8 × 6 in.
Private collection

Zwei verschiedene Ansichten
1977, glasierte Keramik, 10,2 × 20,3 × 15,2 cm
Privatsammlung

B/W Cup Box Series: White

Two different views
1977, glazed ceramic, 8 × 8 × 8 in.
Private collection

Zwei verschiedene Ansichten
1977, glasierte Keramik, 20,3 × 20,3 × 20,3 cm
Privatsammlung

Group Exhibitions (selected)

2005 New Acquisitions Exhibition. World Ceramic Exposition Foundation. Icheon World Ceramic Center. Icheon City, Gyeonggi-do, South Korea 2004 1st Rochester Biennial Inaugural Exhibition. Memorial Art Gallery, Rochester, NY / IAC Members' Exhibition. Organized by the World Ceramic Exposition Foundation. Icheon World Ceramic Center. Icheon City, Gyeonggi-do, South Korea 2003 21st Century Ceramics in the United States and Canada. Columbus College of Art and Design. Columbus, OH / Students and Faculty of the University of Washington Ceramics Program 1969–1996 The Clay Studio. Philadelphia, PA 2002 4 X10: Ceramic Sculpture. The Phillips Museum of Art, The Rothman Gallery, Franklin & Marshall College. Lancaster, PA / Ceramic Modernism: Hans Coper, Lucie Rie and their legacy. The Gardiner Museum of Ceramic Art. Toronto, Ontario, Canada / Contemporary American Ceramics 1950–1990: A Survey of American Objects and Vessels. The National Museum of Modern Art. Kyoto, Japan / 2001 Poetics of Clay: An International Perspective. Curated by Helen W. Drutt English. The Philadelphia Art Alliance. Philadelphia, PA. Additional venues for this exhibition include: The Museum of Art and Design. Taideteollisuusmuseo. Helsinki, Finland; Houston Center for Contemporary Craft. Houston, TX 2000 Color and Fire: Defining Moments in Studio Ceramics, 1950–2000. The Los Angeles County Museum of Art. Los Angeles, CA. Additional venues for this exhibition include: Kemper Museum of Contemporary Art. Kansas City, MO; The Tucson Museum of Art and Historic Block. Tucson, AZ; Memorial Art Gallery of the University of Rochester. Rochester, NY 1999 Clay into Art: Selections from the Collection of Contemporary Ceramics in The Metropolitan Museum of Art. The Metropolitan Museum of Art. New York, NY 1998 The International Ceramic Public Art Exhibition. Taipei County Cultural Center. Banchyao, Taiwan 1997 SOFA: Sculpture Objects Functional Art. Navy Pier. Chicago, IL / The Best in Ceramics. Krannert Art Museum. University of Illinois at Urbana-Champaign, IL 1993 The Contemporary Museum Collects: The First Five Years 1988–1993. The Contemporary Museum. Honolulu, HA 1992 Drawings by Craft Artists. Renwick Gallery. Washington, DC / Seventeen Years: 1974–1991. Helen Drutt Gallery. Philadelphia, PA 1991 Scale-Detail 1991. Habatat-Shaw Gallery. Farmington Hills, MI 1990 Ceramic Invitational. Brigham Young University. Provo, UT / Anne Currier and Wayne Higby. Pewabic Pottery. Detroit, MI 1989 Ceramic Abstractions. Esther Saks Gallery. Chicago, IL 1988 Sculptural Clay. Arvada Center for the Arts and Humanities. Arvada, CO / Off the Pedestal: Clay on the Wall. Village Gate Art Center. Rochester, NY 1987 Six Artists: Two and Three Dimensions. The Society for Art in Crafts. Pittsburgh, PA / American Ceramics Now: Twenty-Seventh Ceramic National Exhibition. Everson Museum of Art. Syracuse, NY; American Craft Museum. New York, NY / National Sculpture Conference: Works by Women. Women's Sculpture Invitational. Cincinnati, OH 1986 Contemporary Crafts: A Concept in Flux. The Society for Art in Crafts. New York, NY and Pittsburgh, PA 1985 Ceramic Art of the '70's: A Review of a Decade. Exhibit A, Gallery of American Ceramics. Chicago, IL / American Clay Artists: Philadelphia '85. The Port of History Museum. Philadelphia, PA 1984 Skidmore Invitational 1984: Multiplicity in Clay, Fiber and Metal. Schick Art Gallery. Skidmore College. Saratoga Springs, NY / Colorado Clay Exhibitions. Foothills Art Center. Golden, CO 1983 A Personal View: Selections from the Joan Mannheimer Ceramic Collection. University of Missouri-Kansas City. Kansas City, MO / SOUP SOUP Beautiful SOUP. Campbell Museum. Camden, NJ 1982 Arts '82. Boulder Center for the Visual Arts. Boulder, CO 1981 12th Annual Ceramics Invitational. Crossman Gallery Center for the Arts. Whitewater, WI 1980 6th Colorado Annual. Stanton Gallery,

Gallery, St. Louis, MO / Kavesh Gallery, Ketchum, ID 1990 Helen Drutt Gallery, New York, NY 1988 Helen Drutt Gallery, Philadelphia, PA 1985 Helen Drutt Gallery, Philadelphia, PA 1984 Carson Sapiro Gallery, Denver, CO 1981 Carson Sapiro Gallery, Denver, CO 1980 Exhibit A Gallery, Chicago, IL

Gruppenausstellungen (Auswahl)

2005 New Acquisitions Exhibition. World Ceramic Exposition Foundation. Icheon World Ceramic Center. Icheon City, Gyeonggi-do, Süd-Korea 2004 1st Rochester Biennial Inaugural Exhibition. Memorial Art Gallery, Rochester, NY / IAC Members' Exhibition. Organisiert von der World Ceramic Exposition Foundation. Icheon World Ceramic Center. Icheon City, Gyeonggi-do, Süd-Korea 2003 21st Century Ceramics in the United States and Canada. Columbus College of Art and Design. Columbus, OH / Students and Faculty of the University of Washington Ceramics Program 1969–1996 The Clay Studio. Philadelphia, PA 2002 4 X10: Ceramic Sculpture. The Phillips Museum of Art, The Rothman Gallery, Franklin & Marshall College. Lancaster, PA / Ceramic Modernism: Hans Coper, Lucie Rie and their legacy. The Gardiner Museum of Ceramic Art. Toronto, Ontario, Kanada / Contemporary American Ceramics 1950–1990: A Survey of American Objects and Vessels. The National Museum of Modern Art. Kyoto, Japan / 2001 Poetics of Clay: An International Perspective. Kuratiert von Helen W. Drutt English. The Philadelphia Art Alliance. Philadelphia, PA. Weitere Ausstellungsorte: The Museum of Art and Design. Taideteollisuusmuseo. Helsinki, Finnland; Houston Center for Contemporary Craft. Houston, TX 2000 Color and Fire: Defining Moments in Studio Ceramics, 1950–2000. The Los Angeles County Museum of Art. Los Angeles, CA. Weitere Ausstellungsorte: Kemper Museum of Contemporary Art. Kansas City, MO; The Tucson Museum of Art and Historic Block. Tucson, AZ; Memorial Art Gallery of the University of Rochester. Rochester, NY 1999 Clay into Art: Selections from the Collection of Contemporary Ceramics in The Metropolitan Museum of Art. The Metropolitan Museum of Art. New York, NY 1998 The International Ceramic Public Art Exhibition. Taipei County Cultural Center. Banchyao, Taiwan 1997 SOFA: Sculpture Objects Functional Art. Navy Pier. Chicago, IL / The Best in Contemporary Clay. Miller Gallery. Cincinnati, OH / Centennial Exhibitions: Trends in Contemporary Craft Exhibition. The Society of Arts and Crafts. Boston, MA 1996 Signatures. Fosdick-Nelson Gallery. NYS College of Ceramics. Alfred, NY / Alfred Teaches Ceramics: 1900 to 1996. International Museum of Ceramic Art. New York, NY 1994 Alfred Now: Contemporary American Ceramics. Krannert Art Museum. University of Illinois at Urbana-Champaign, IL 1993 The Contemporary Museum Collects: The First Five Years 1988–1993. The Contemporary Museum. Honolulu, HA 1992 Drawings by Craft Artists. Renwick Gallery. Washington, DC / Seventeen Years: 1974–1991. Helen Drutt Gallery. Philadelphia, PA 1991 Scale-Detail 1991. Habatat-Shaw Gallery. Farmington Hills, MI 1990 Ceramic Invitational. Brigham Young University. Provo, UT / Anne Currier and Wayne Higby. Pewabic Pottery. Detroit, MI 1989 Ceramic Abstractions. Esther Saks Gallery. Chicago, IL 1988 Sculptural Clay. Arvada Center for the Arts and Humanities. Arvada, CO / Off the Pedestal: Clay on the Wall. Village Gate Art Center. Rochester, NY 1987 Six Artists: Two and Three Dimensions. The Society for Art in Crafts. Pittsburgh, PA / American Ceramics Now: Twenty-Seventh Ceramic National Exhibition. Everson Museum of Art. Syracuse, NY; American Craft Museum. New York, NY / National Sculpture Conference: Works by Women. Women's Sculpture Invitational. Cincinnati, OH 1986 Contemporary Crafts: A Concept in Flux. The Society for Art in Crafts. New York, NY and Pittsburgh, PA 1985 Ceramic Art of the '70's: A Review of a Decade. Exhibit A, Gallery of American Ceramics. Chicago, IL / American Clay Artists: Philadelphia '85. The Port of History Museum. Philadelphia, PA 1984 Skidmore Invitational 1984: Multiplicity in Clay, Fiber and Metal. Schick Art Gallery. Skidmore College. Saratoga Springs, NY / Colorado Clay Exhibitions. Foothills Art Center. Golden, CO 1983 A Personal View: Selections from the Joan Mannheimer Ceramic Collection. University of Missouri-Kansas City. Kansas City, MO / SOUP SOUP Beautiful

SOUP. Campbell Museum, Camden, NJ 1982 Arts '82. Boulder Center for the Visual Arts. Boulder, CO 1981 12th Annual Ceramics Invitational. Crossman Gallery Center for the Arts. Whitewater, WI 1980 6th Colorado Annual. Stanton Gallery, Denver Art Museum. Denver, CO / Viewpoint '80: Art in Craft Media. The Museum of Texas Tech University. Lubbock, TX 1978 Colorado Crafts: 17 Views. Denver Art Museum. Denver, CO / 34th Annual Ceramics Invitational. Lang Art Gallery Scripps College. Claremont, CA / Clay-Fiber-Metal by Women Artists. Bronx Museum of the Arts. Bronx, NY / 5th Colorado Annual. Stanton Gallery, Denver Art Museum. Denver, CO 1977 Drinking Companions. Kohler Arts Center. Sheboygan, WI / 4th Annual California Ceramic and Glass Exhibition. Palo Alto, CA 1976 Boxes. Polly Friedlander Gallery. Seattle, WA / Eight-State Annual: Crafts. J.B. Speed Art Museum. Louisville, KY / 4th Colorado Annual. Denver Art Museum. Denver, CO 1975 15th Annual Mid-States Craft Exhibit. Evansville Museum of Arts and Sciences. Evansville, IN 1974 Designer/ Craftsman '74. Richmond Art Center. Richmond, CA 1973 Ceramic Art of the World 1973. University of Calgary. Alberta, Kanada

Publikationen mit Werkbeispielen (Auswahl)

Bill Hunt (Hg.), 21st Century Ceramics in the United States and Canada (Westerville, OH: American Ceramics Society, 2003) / Ching Wan Yin and Lu Pinchang (Hg.), World Relief Art, all Chinese text (China: 2002) / Susan Peterson, Contemporary Ceramics (New York, NY: Watson-Guptill, 2001) / Richard Zakin, Ceramics: Mastering the Craft (Iola, WI: Krause Publications, Inc., 2001) / Daniel Rhodes, Clay and Glazes for the Potter, erweitert und überarbeitet von Robin Hopper (Iola, WI: Krause Publications, Inc.., 2000) / Jo Lauria, Color and Fire: Defining Moments in Studio Ceramics, 1950–2000 (New York, NY: Rizzoli International Publications, Inc., in association with LACMA, 2000) / Jane Adlin, Contemporary Ceramics: Selections from The Metropolitan Museum of Art (New York, NY: The Metropolitan Museum of Art, 1998) / Nouvel Objet III (Seoul, South Korea: Design House Publications, 1997) / Robert Piepenburg, The Spirit of Clay: A Classic Guide to Ceramics (Ann Arbor, MI: Pebble Press, 1996) / Susan Peterson, The Craft and Art of Clay (Upper Saddle River, NJ: Prentice Hall, 2. Auflage: 1996; 3. Auflage: 1998; 4. Auflage: 2003) / Peter Dormer, The New Ceramics: Trends and Traditions, überarbeitete Ausgabe (New York, NY: Thames and Hudson, 1994) / Martina Margetts (Hg.), International Crafts (London: Thames & Hudson, 1991) / Elaine Levine, The History of American Ceramics: 1607 to the Present (New York, NY: Abrams, Inc., 1988) / Garth Clark, American Ceramics: 1876 to the Present (New York, NY: Abbeville Press, 1987) / Susan Welcher, Low Fire Ceramics (New York, NY: Watson-Guptill, 1981) / LaMar Harrington, Ceramics in the Pacific Northwest: A History (Seattle, WA: University of Washington Press, 1979) / Glenn C. Nelson, Ceramics: A Potter's Handbook, 4. Auflage (Orlando, FL: Holt, Rinehart & Winston, 1978).

Öffentliche Sammlungen (Auswahl)

Los Angeles County Museum of Art, Los Angeles, CA / Metropolitan Museum of Art, New York, NY / Museum of Contemporary Art, Kyoung-ju, Süd-Korea / Renwick Gallery, Smithsonian American Art Museum, Washington, DC / Memorial Art Gallery, Rochester, NY / Daum Museum of Contemporary Art, Sedalia, MO / Le Musée des Beaux-Arts de Montréal, Québec, Kanada / Schein-Joseph International Museum of Ceramic Art, New York State College of Ceramics at Alfred University, Alfred, NY / The Contemporary Museum, Honolulu, HA / Museum of Arts and Design, New York, NY / Racine Museum of Fine Art, Racine, WI / MacKenzie Fine Arts Center, Dearborn, MI / University of Calgary, Alberta, Kanada / University of Colorado, Boulder, CO / World Ceramic Exposition Foundation, Icheon World Ceramic Center, Icheon City, Gyeonggi-do, Süd-Korea

Auftragsarbeiten

1997–1998 Miller Performing Arts Building, Alfred University, Alfred, NY
1993–1994 Arrow International, Inc. Corporate headquarters, Reading, PA

Denver Art Museum. Denver, CO / Viewpoint '80: Art in Craft Media. The Museum of Texas Tech University. Lubbock, TX 1978 Colorado Crafts: 17 Views. Denver Art Museum. Denver, CO / 34th Annual Ceramics Invitational. Lang Art Gallery Scripps College. Claremont, CA / Clay-Fiber-Metal by Women Artists. Bronx Museum of the Arts. Bronx, NY / 5th Colorado Annual. Stanton Gallery, Denver Art Museum. Denver, CO 1977 Drinking Companions. Kohler Arts Center. Sheboygan, WI / 4th Annual California Ceramic and Glass Exhibition. Palo Alto, CA 1976 Boxes. Polly Friedlander Gallery. Seattle, WA / Eight-State Annual: Crafts. J.B. Speed Art Museum. Louisville, KY / 4th Colorado Annual. Denver Art Museum. Denver, CO 1975 15th Annual Mid-States Craft Exhibit. Evansville, IN 1974 Designer/ Craftsman '74. Richmond Art Center. Richmond, CA 1973 Ceramic Art of the World 1973. University of Calgary. Alberta, Canada

Publications with Examples of Work (selected)

Bill Hunt (ed.), 21st Century Ceramics in the United States and Canada (Westerville, OH: American Ceramics Society, 2003) / Ching Wan Yin and Lu Pinchang (eds.), World Relief Art, all Chinese text (China: 2002) / Susan Peterson, Contemporary Ceramics (New York, NY: Watson-Guptill, 2001) / Richard Zakin, Ceramics: Mastering the Craft (Iola, WI: Krause Publications, Inc., 2001) / Daniel Rhodes, Clay and Glazes for the Potter, expanded and revised by Robin Hopper (Iola, WI: Krause Publications, Inc., 2000) / Jo Lauria, Color and Fire: Defining Moments in Studio Ceramics, 1950–2000 (New York, NY: Rizzoli International Publications, Inc., in association with LACMA, 2000) / Jane Adlin, Contemporary Ceramics: Selections from The Metropolitan Museum of Art (New York, NY: The Metropolitan Museum of Art, 1998) / Nouvel Objet III (Seoul, South Korea: Design House Publications, 1997) / Robert Piepenburg, The Spirit of Clay: A Classic Guide to Ceramics (Ann Arbor, MI: Pebble Press, 1996) / Susan Peterson, The Craft and Art of Clay (Upper Saddle River, NJ: Prentice Hall, 2nd edition: 1996; 3rd edition: 1998; 4th edition: 2003) / Peter Dormer, The New Ceramics: Trends and Traditions, revised edition (New York, NY: Thames and Hudson, 1994) / Martina Margetts (ed.), International Crafts (London: Thames & Hudson, 1991) / Elaine Levine, The History of American Ceramics: 1607 to the Present (New York, NY: Abrams, Inc., 1988) / Garth Clark, American Ceramics: 1876 to the Present (New York, NY: Abbeville Press, 1987) / Susan Welcher, Low Fire Ceramics (New York, NY: Watson-Guptill, 1981) / LaMar Harrington, Ceramics in the Pacific Northwest: A History (Seattle, WA: University of Washington Press, 1979) / Glenn C. Nelson, Ceramics: A Potter's Handbook, 4th edition (Orlando, FL: Holt, Rinehart & Winston, 1978).

Public Collections (selected)

Los Angeles County Museum of Art, Los Angeles, CA / Metropolitan Museum of Art, New York, NY / Museum of Contemporary Art, Kyoung-ju, South Korea / Renwick Gallery, Smithsonian American Art Museum, Washington, DC / Memorial Art Gallery, Rochester, NY / Daum Museum of Contemporary Art, Sedalia, MO / Le Musée des Beaux-Arts de Montréal, Québec, Canada / Schein-Joseph International Museum of Ceramic Art, New York State College of Ceramics at Alfred University, Alfred, NY / The Contemporary Museum, Honolulu, HA / Museum of Arts and Design, New York, NY / Racine Museum of Fine Art, Racine, WI / MacKenzie Fine Arts Center, Dearborn, MI / University of Calgary, Alberta, Canada / University of Colorado, Boulder, CO / World Ceramic Exposition Foundation, Icheon World Ceramic Center, Icheon City, Gyeonggi-do, South Korea

Commissions

1997–1998 Miller Performing Arts Building, Alfred University, Alfred, NY
1993–1994 Arrow International, Inc. Corporate headquarters, Reading, PA

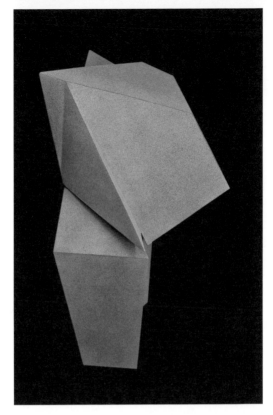

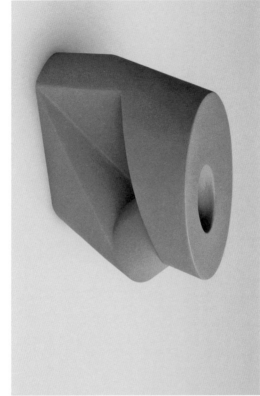

Core Reversal

1979, glazed ceramic, 4.5 × 5 × 6 in.
Private collection

1979, glasierte Keramik, 11,4 × 12,7 × 15,2 cm
Privatsammlung

LFC

1980, glazed ceramic, 11 × 26 × 14 in.
Private collection

1980, glasierte Keramik, 27,9 × 65,9 × 35,5 cm
Privatsammlung

Diptych (PK)

1982, glazed ceramic, 20 × 39 × 28 in.
Private collection

1982, glasierte Keramik, 50,8 × 99 × 71,1 cm
Privatsammlung

Cupreous Resorption

1986, glazed ceramic, 11 × 27 × 7 in.
Barbara Bluhm, USA

1986, glasierte Keramik, 27,9 × 68,5 × 43,1 cm
Barbara Bluhm, USA

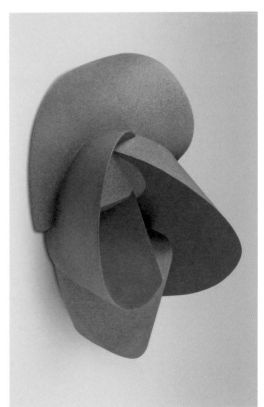

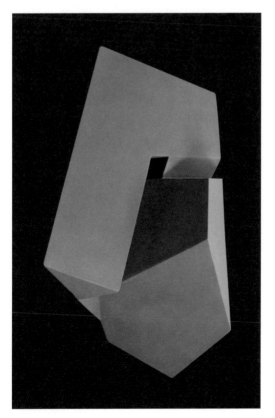